How to take great family photos

Cathy Joseph and Angela Hampton

15 36 ▷ 15A

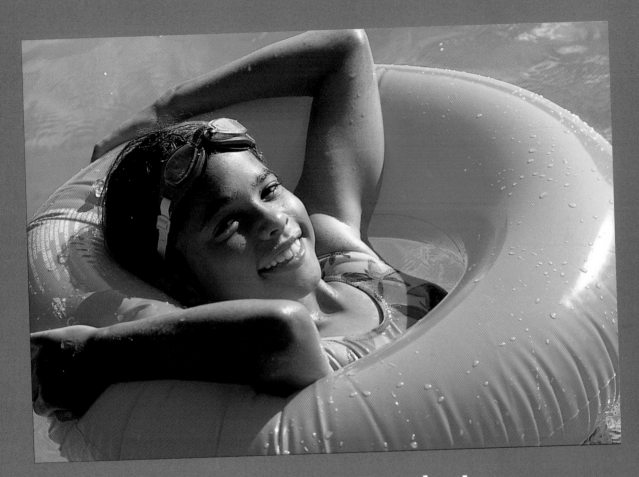

How to take great family photos

Cathy Joseph and Angela Hampton

15 36 ⊳ 15A

RotoVision

A RotoVision Book
Published and distributed by RotoVision SA,
Route Suisse 9, CH-1295 Mies
Switzerland

RotoVision SA, Sales, Editorial & Production Office
Sheridan House, 112/116a Western Road
Hove, East Sussex BN3 1DD, UK

Tel: +44 (0)1273 72 72 68
Fax: +44 (0)1273 72 72 69
Email: sales@rotovision.com
Website: www.rotovision.com

10 9 8 7 6 5 4 3 2 1

ISBN 2-88046-746-2

Designed by **Balley Design Associates,** Brighton
All photography by **Angela Hampton**

Origination and printing in Singapore
by ProVision Pte. Ltd.
Tel: +65 6334 7720
Fax: +65 6334 7721

introduction 006
rogues' gallery 008

1 getting started

how the camera works 016
choosing a camera 018
accessories 020
film 022
how to hold your camera 024

2 composition

learning to look 028
selecting a focal point 030
positioning the subject 034
posing 038
framing the subject 046
camera angles 048
color and props 050

3 lighting

brightness, color, quality 056
outdoor light 058
indoor light 062
using flash 066

4 family subjects

family ties 072
babies 074
children 078
siblings 082
teenagers 084
pets 086
couples 090
grandparents 092
family groups 094

5 special occasions

everlasting memories 100
weddings 102
vacations 104
christmas and birthdays 108
school events 110

6 after the pictures are taken

organizing your pictures 114
processing and printing 116
digital imaging 118
building a picture story 120
creating an album 122
enlarging and framing 124
cut out and keep: 20 questions to ask yourself 126

acknowledgments 127
index 128

introduction

For most people, photography is neither a profession nor a special hobby, yet virtually everyone enjoys taking or looking at family photos. It's wonderful to have an enduring record of precious moments like a baby's first steps, a wedding or simply the children having fun on holiday.

Most of us are guilty of hoarding too many bad photos. To add insult to injury, we inflict boredom on friends and family who have to plow through meaningless sets of pictures when only a handful are worth keeping. If we aren't happy with them, why should anyone else be?

Whether we are confident—or not—with a camera, we all like to be satisfied with the pictures we take. Not just for our own benefit, but so we can show them around without people groaning that we've made them look awful, given them a double chin and an unattractive stoop. There's always a sense of anticipation and excitement about picking up prints from the processors. Why is it that, all too often, it's followed by a wave of disappointment? The pictures are dark, the background's messy, mom looks ten years older, dad's been decapitated, the baby's a red-eyed devil, and uncle's grin looks like he's had a hernia.

Photography is not just about pressing the shutter button the minute you lift the camera. A number of thought processes should occur first, most of which will happen within a split second once you've learned how to use the camera and your eye becomes practiced.

It's just like learning to drive a car. You don't just put your foot on the accelerator and zoom off—you take lessons. At first you're baffled by the controls and how they work in unison. Eventually you understand how the controls operate and become confident that you're in charge of the car, not the other way around. You use your pedals, mirror, and signals without needing to think as you did in the early days.

You really do not have to be an expert to take great pictures. You simply need to learn a few basics and take time to practice them, until assessing what will make a good shot becomes as automatic as driving a car.

Whether you own a basic compact camera or a more sophisticated SLR, this book will give you uncomplicated guidance towards getting the kind of shots you always wanted. Each chapter covers some of the basic elements of photography and explains how to prevent common mistakes such as blurred pictures, poor composition, red-eye, and bad lighting. There are also practical exercises to improve your technique and measure your success. You'll learn to judge the merits of a picture before pressing the shutter, saving you time and money on film and processing.

The aim of this book is to help you exploit your camera as a means to an end: sharp, uncluttered, well-composed, and flattering portraits which the whole family will enjoy for many years to come.

We all make mistakes, and often it helps to identify the problems. Let's begin the book by looking at some of the common culprits. By doing so, the rest of the book will make much more sense. If your shots look more like those on the left than on the right, read on to find the answers.

kids on funfair ride

problem	reason	solution
■ Too dark	■ Flash too far from the subject	■ Keep to brighter conditions
■ Subjects too small in the frame	■ Photographer should have used a zoom lens, or chosen a better viewpoint	■ Going in close with a zoom lens makes the children the main element in the picture
■ White strip on the right-hand side of the image	■ Pillar lit up by the flash	■ Careful timing catches a great expression on the girls' faces

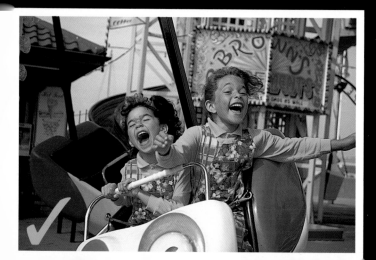

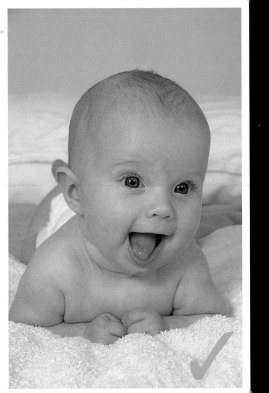

woman on beach

problem
- Yellow pole is badly positioned behind her head
- Boring composition
- Too much plain sky
- Subject is too small in the picture

reason
- Lack of observation
- Subject is in too central a position in the frame
- Photographer is too far away from the subject
- Photographer has made wrong lens choice

solution
- Scan all areas of the unwanted distraction
- Move the camera so the right or left of the
- Get in close to the s more impact
- Select a more appro that the subject fills

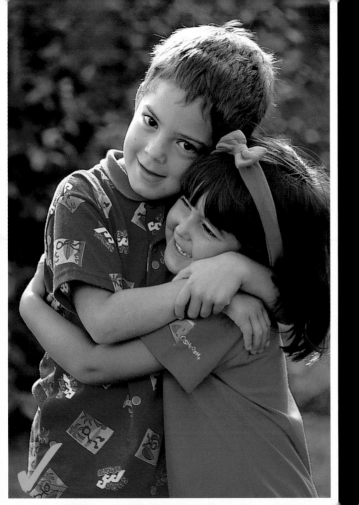

portrait of man

mother and children

problem
- Dark shadows under their eyes
- Girls are squinting
- Red pole of swing cuts corner off frame

reason
- Shooting with strong sunshine behind photographer and in front of the subject
- Bad composition. Bright red pole draws the eye to it

solution
- Placing the subjects with the sun behind them produces an attractive backlight effect, making their hair glow
- A close-up portrait of the subject has greater impact
- Be aware of the subjects' arms. This arrangement links them together nicely

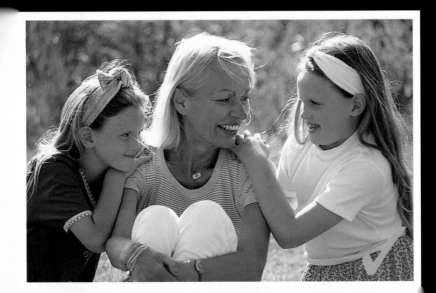

getting started

FUJI RDPII

1

how the camera works

A camera is a light-tight box with a lens at one end and film at the other. Inside the lens is a hole, or aperture, which controls the amount of light entering the lens. The size of the aperture is set by something called an f-stop. The larger the f-stop number, the smaller the aperture. F-stops also determine which parts of your picture will be in focus.

When you press the shutter button, a window opens, enabling light to pass through the aperture to the light-sensitive film. Digital cameras require no film but have a silicon chip made up of a million or more pixels. When the shutter is pressed and light enters the lens, electronics scan the array of pixels, which make up the picture.

Two things determine exposure of film: the size of aperture and the shutter speed (length of time the light has to enter the aperture). So, together, the f-stop and shutter speed make up the right measurement of exposure.

If the shutter is open for the correct length of time but the aperture is too wide, your picture will overexpose. The same thing will happen if the aperture is set correctly but the shutter is open too long. Conversely, if your aperture is too narrow but the shutter speed is correct, your picture will underexpose. The right aperture but too fast a shutter speed will also result in underexposure. If both shutter speed and aperture are incorrectly set, you are in trouble!

By way of an example, let's assume your correct exposure is f8 at $\frac{1}{125}$th of a second (typical for a slightly overcast day):

f8	**@**	**$\frac{1}{125}$th second = correct exposure**
f8	**@**	**$\frac{1}{500}$th second = underexposed**
f11	**@**	**$\frac{1}{125}$th second = underexposed**
f8	**@**	**$\frac{1}{30}$th second = overexposed**
f5.6	**@**	**$\frac{1}{125}$th second = overexposed**

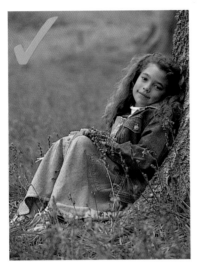

correct exposure

overexposed

underexposed

The good news is that if you are using a fully automated camera, you don't have to worry about any of this! Compact cameras come with in-built f-stops and shutter speeds, and in most situations it will be just fine. It's only when you want to have more control over your photography, or use your camera in tricky lighting situations, that you may want to consider taking over the exposure manually.

Remember: the lower the lighting conditions, the more light needed to expose the film. The more light needed, the wider the aperture and the slower the shutter speed. To get around this, use fast film.

choosing a camera

compacts

Compacts are popular because they are simple to use, affordable, and lightweight. The range of models available has never been greater, and because they work out exposure for you, you have more time to compose pictures.

At the cheap end of the scale are the point-and-shoot 'instamatics'. They're great for kids but the quality is limited, and their plastic bodies won't withstand hard use. Spend more money and you'll gain features, greater versatility, and a better lens.

There are two types of compacts: those with a single focal length lens, and those with a zoom lens. The former types come in fixed or autofocus models. A single focal length usually has a wide angle of view, set at around 35mm. The wider the lens, the more you get in the frame. Hence, wide angles are good for pictures such as groups of people or landscapes, but they are impractical for close-ups. You cannot get within close range of the subject; there is too much space around it, and wide angles can distort features. The great thing about a zoom lens is that you can recompose your shot without moving, zooming in for a close angle, or out for a wider view, and without distorting the subject. The length of zoom lens you choose will depend on the pictures you intend to take.

APS cameras

APS (Advanced Photo System) cameras are an alternative to conventional 35mm cameras. Their advantages are that you can shoot in different print formats (standard, wide, and panoramic), change the film in the middle of the roll, process it again from the cassette, and record date and time. Their disadvantage is that they tend to be more expensive, although that is certain to change in time.

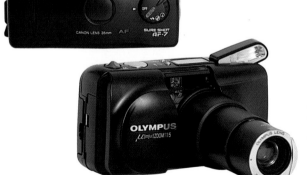

top left > A basic compact will have a fixed focal length lens, usually 35mm, and a built-in flash.

bottom left > A more advanced compact will have a zoom lens, which is extremely useful for composing the subject or taking pictures from a distance, plus a self-timer facility.

top right > An SLR camera has interchangeable lenses—so you can select the correct focal length for the subject. Modern models have built-in flash units that pop up at the top of the camera. You can also attach a flashgun.

bottom right > Digital compacts look much the same as ordinary compact cameras but pictures are stored on a memory card rather than on film.

SLR cameras

Unlike a compact, SLR (single-lens reflex) means that the camera uses a single lens, so that what you see through the viewfinder is what you get in the picture.

An advantage of SLRs is that you can remove and add any focal length lens. The manual SLR has been virtually abandoned in favor of electronic versions, which offer full automation and autofocus but with the option of setting the exposure manually if you want to. Older SLR models have manual focusing lenses, and if you're serious about photography, this is the best option—the f-stops and shutter speeds start to make sense.

digital cameras

It's not surprising that digital photography has taken off. No more film to buy, or anxious waiting. It is instant. The more popular digital cameras become, the cheaper they get, although quality increases the more you pay. They are just as simple to use as conventional compacts, and share many of the same features, with a few differences.

Instead of using film, a digital camera stores pictures in its memory via a memory card. The great thing about this is that it can be wiped clean and used again. A digital picture is made up of pixels, which are light-sensitive squares. The greater the number of pixels, the better the image resolution.

Imaging software often comes with the camera and means you can improve your pictures without having to scan them. Your images can be downloaded to a computer to print out or e-mail. Alternatively, a photo lab can make glossy prints for you.

accessories

tripods

A tripod offsets the risk of camera shake. This often happens when available light is low and you need a slow shutter speed. If the camera is not kept absolutely still during the exposure, your pictures will come out blurred. If you press the button too hard and move the camera, or there's a high wind, you'll also have unsharp pictures. A fast film will help increase the shutter speed if low light is a problem. Or you could use flash, but that can spoil the atmosphere. If in doubt, use a tripod. It may be a little inconvenient at first, but you'll soon get used to the idea, at least for your important shots.

Tripods come in various sizes, weights, and materials. A lightweight tripod is better than none at all and is fine for compacts, but it won't support a heavy camera or stand up in strong winds. Choose one to suit your needs, and remember to try one with your camera before you buy.

filters

Filters are circular pieces of glass or resin that fit onto the lens of SLR cameras. They can manipulate color as well as produce special effects. The most popular is a polarizing filter, which is useful for cutting out reflections when you're shooting through glass or taking pictures in a swimming pool. It will also deepen the color of a blue sky.

Soft-focus filters are not as fashionable as they used to be. They diffuse images for an angelic look. You can create a similar effect by smearing petroleum jelly or clear nail varnish on a clear protective filter. Warm-up filters come in varying strengths and add glow to skin tones, but these should be used sparingly.

reflectors

These are white, gold, or silver and reflect light back onto the subject. If you sit a person beside a window, for example, one side of will be in shadow while the other will be lit up by window light. Holding up a reflector on the dark side will bounce light into the shadow area so that the subject is more evenly lit. You can buy ready-made reflectors in small or large sizes, or make your own with a white sheet, towel, piece of card, or baking foil.

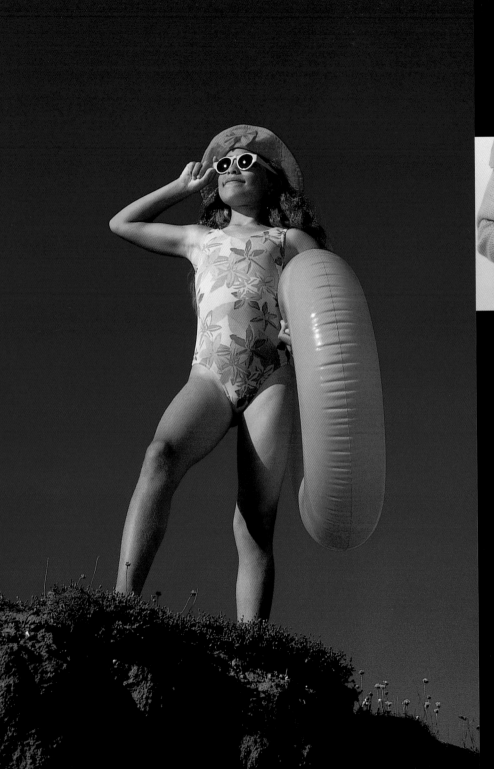

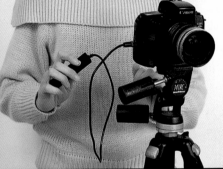

left > A polarizing filter can deepen a
blue sky for added impact.

above > Tripods are necessary to
prevent camera shake during long
exposures. For extra insurance use a
cable release. This is a length of cable
with a plunger attached, allowing you to
fire the shutter from a distance and thus
avoid putting pressure on the camera
body. It's also useful if you want to talk to
your subject without having to peer
through the viewfinder.

film

Your choice of film depends on the type of lighting you'll be using it in. Films can be purchased in a range of 'speeds' denoted by an ISO number. The higher the ISO number, the 'faster' the film, meaning you need less light coming into the camera. The lower the number, the more light is needed. A 100 ISO film is best for sunny days outdoors and flash indoors. A 200 ISO film is a good all-rounder as it can be used in all weathers. A 400 ISO film is ideal for poor light.

types of film

Color print films are most popular. They have a wide exposure latitude, meaning that if you have under- or overexposed your film it can be rectified. Prints can be enlarged to almost any size from negatives, but if you need big enlargements it is best to go for a 100 ISO film which has the finest grain. A 400 ISO film will give a grainier print, and the larger the print, the more identifiable the grain. APS film is available at the same ISO speeds as 35mm film but in smaller cartridges.

Color slide film, indicated by the words 'chrome' (e.g. Fujichrome), produces transparencies (slides) mounted in plastic frames instead of negatives. They are not as forgiving as negative films, so accurate exposures are critical. Like prints, slides can be scanned onto a computer and prints made from them. Processing labs can also make prints from slides but it's more expensive than producing them from negatives.

Black-and-white film has timeless appeal. It can also be a good choice if the weather is dull or if there are too many distracting colors in a scene. It is used in the same way as color negative film, although not all labs will print it.

right > **Black-and-white is great for atmospheric portraits. The available light was quite low for this example so a fast-speed film was used. This has more visible grain on a print than slow-speed film but that can add to the mood of a picture.**

left > **With color transparency film you can put on your own slide show if you have a projector. The quality is generally better than print film which makes it the best choice for publication.**

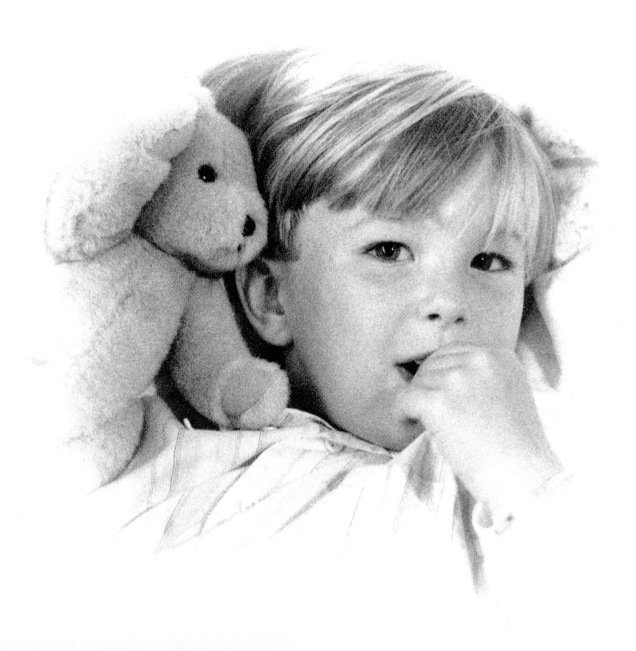

how to hold your camera

Basically, supporting your camera properly entails keeping the camera straight; ensuring your fingers are out of the way, and eliminating camera shake. If you've had blurred pictures in the past, you probably moved the camera during the exposure. Blobs or black areas in the print are evidence that something, probably a thumb, was blocking part of the lens; this is easily done with compacts when you can't see it through the viewfinder.

Start by holding the camera horizontally. Grip firmly in both hands. The right hand can take the main weight of the camera, the left takes the rest, or vice versa, depending where the grip is. (On SLR cameras, the lens rests in the left hand, which also adjusts the focusing ring in manual mode). The right forefinger is then free to press the shutter on top of the camera. If the shutter button is at the back of the camera, use your thumb to press it.

ideas to try

1 In an area where there is plenty of light, stick something with a straight edge on the wall next to a mirror, at eye level, such as a sheet of newspaper. Stand in front of the mirror holding the camera horizontally. Check that you are balanced and steady. Line up your camera with the edge of the newspaper. Finally, check that the flash is turned off.

2 In vertical position, ensuring that your camera is straight, see how long you can steady the camera without shaking.

3 Press the shutter release fully and check in the mirror if your camera is still aligned.

Next, pull both elbows tightly towards the torso. Stand with feet hip-width apart, weight evenly distributed. Think of pulling up energy from the ground, through the legs. Breathe in and press the camera to the eye, making sure it's level. If you have a horizon in view, use this as a spirit level.

Now hold the camera vertically. You do this by dropping the camera to the left and stabilizing in the same way. Finally, depress the shutter—gently—without tilting or jerking the camera. Don't be fooled if the camera is light. It's much easier to experience camera shake with a lightweight camera than a heavy one.

ask yourself

- Is my camera turned on, and the lens cap off?
- Is it straight or lopsided?
- Is my finger or camera strap covering the lens, flash unit, or metering sensor?

above > **Make sure to support your camera to avoid blurred pictures.**

left > **If you don't have a tripod with you in windy weather or low light, try to find a stable support to brace yourself against to keep the camera steady.**

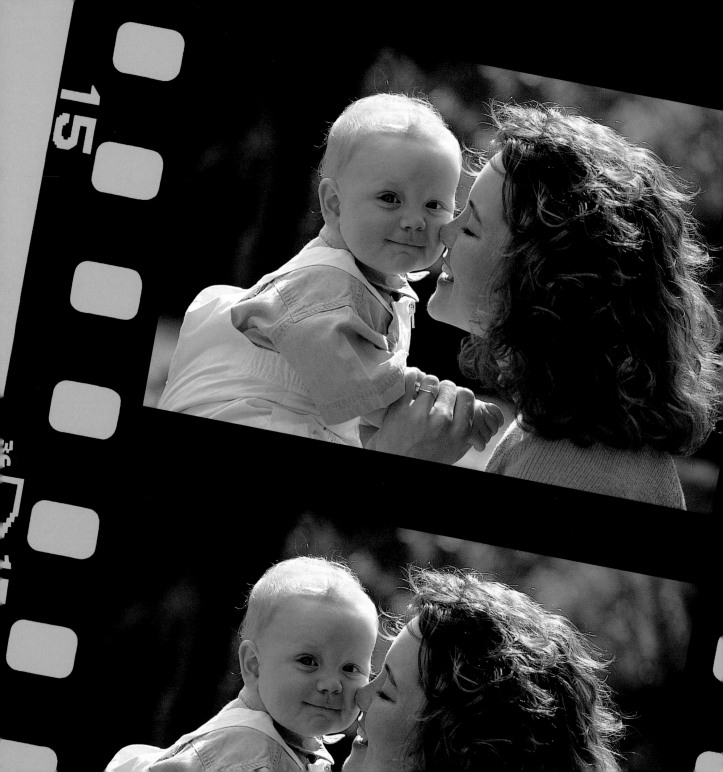

composition

2

learning to look

If you look out of your window at the garden, you can see how tidy it is (or not). The longer you look, the more you notice. You begin to find fault with little things, and think of ways of improving it. Maybe the borders need a trim. If only that rose bush had been planted a few more inches to the right, it would fill that empty space. Perhaps a garden feature would enhance the overall picture.

In the same way, you can accept what you see in your viewfinder, or you can tidy it up. That little rectangle is your window on the world, as you choose to see it. Use the viewfinder as your picture frame.

While you may well decide what you want to achieve before picking up the camera, it's only when you put it to your eye that you'll compose the picture. No amount of fancy equipment will give you an interesting photo unless you choose an interesting composition. How often have you heard the comment that someone 'has an eye for a picture'? It means that someone has an eye for composition.

ask yourself

- What is my main subject?
- What do I want to say?
- Is anything drawing my eye away from the main subject?
- Is anything protruding into the viewfinder?
- Are there any objects growing out of my subject's head?

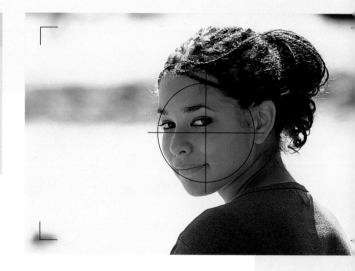

right > Compact camera viewfinders have a grid in which to compose the subject. With color print film, you can allow a little more space but generally, areas outside of it will not be recorded. On autofocus compacts, the viewfinder has a central autofocus ring. This is the area that will be in sharpest focus.

left > **The strong composition is spoilt by the red detail on the table, the edge of the picture frame on the wall and clutter in the background. Look carefully for such distractions, and crop them out.**

ideas to try

Standing in any room, or in the garden:

1 Point the camera at different areas and scan the edges of your frame. Is your image well-composed?

2 Put a family member wearing dark colors somewhere in your picture. Throw some clutter on the floor. Look through the viewfinder. Where is your eye drawn? Zoom in to crop out the clutter. What do you see now?

3 Remove the clutter and ask your subject to wear something bright: yellow or red is good. Note the difference.

Spend time looking through the viewfinder without taking any shots. Scan the edges of the frame, first making sure nothing is intruding, such as the leaf of a plant, a piece of furniture, or a light bulb. The camera has a habit of recording things that did not appear to be in the shot when you took it.

The eye is always led to the brightest area of a picture. Any distracting items near your subject will draw your eye away from it. Watch out for anything that doesn't belong in the picture. If it doesn't add to the composition, get rid of it. Tidy up your viewfinder.

selecting a focal point

If you've practiced using the viewfinder and tried out the ideas, you'll have seen that the eye is drawn to brightness. It's also attracted to sharpness—that is the part of your picture in focus. If you have poor eyesight, you'll appreciate how frustrating it is to look at a page of blurred print. You want a pair of spectacles to sharpen it.

Take a look at something in the distance and notice how the area immediately in front of you is blurred. Now take a look at what is in front of you and see how the distance is blurred. Your eyes can only focus on one area at a time.

When you create a picture, you need to tell your camera what to focus on. It could be grandma reading in an armchair, or it could just be her face. Maybe a cat is sitting behind her on the window sill. What would you focus on then? It depends on whether the cat can tell you something about grandma's character. If that's so, you want them both to be in focus, since the whole, and not part, of the picture tells a story.

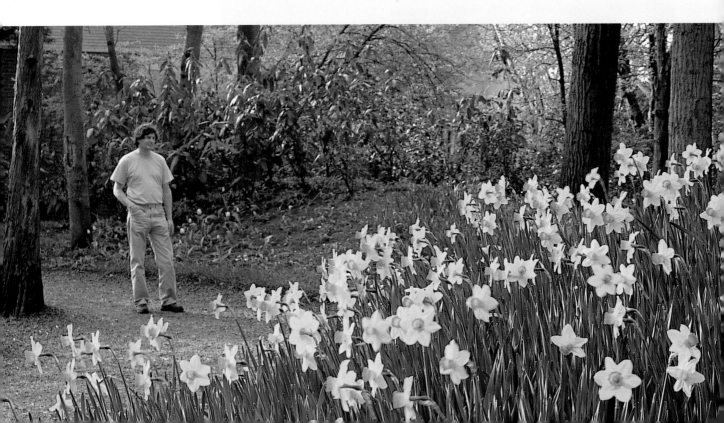

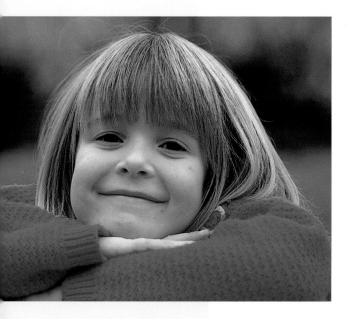

ideas to try

Ask a family member to stand outside, with buildings in the distance:

1 Compose your picture with space around them and include a foreground subject. Use your lens at its widest angle. Set your camera to landscape mode, or at an aperture of f22. Take a picture and make a note of your camera settings.

2 Use your zoom lens to crop in on the subject. Focus your camera on them, using the 'portrait' symbol, or an aperture of f5.6. Take a picture and make a note of your settings.

Compare areas of sharpness and blurring in both pictures. Which one makes the subject stand out as the focal point?

depth of field

Two factors control what is in focus: the aperture and the length of your lens. The area in focus is called the depth of field. This is the zone of acceptable sharpness and is one-third in front of the subject and two-thirds behind. The smaller the aperture opening, the greater the depth of field; the larger the aperture opening, the shorter the depth of field. A fixed focal lens can give you only a wide depth of field; a long lens will give you a short depth of field. A zoom lens, with multiple focal lengths, will allow you to vary your depth of field.

Your lens also controls perspective. Long lenses compress what is in front of them. Short lenses (28mm to 35mm) make things look further apart. A standard lens (50mm) will give you a natural perspective, in other words, what the eye sees.

left > **If you place something in front of your subject and keep it sharp using a wide depth of field, it can lead the viewer's eye into the picture and provide interest in the foreground.**

above > **Use a short depth of field to keep the main subject sharp against a blurred background. It helps to draw the eye towards the person without distracting details around them.**

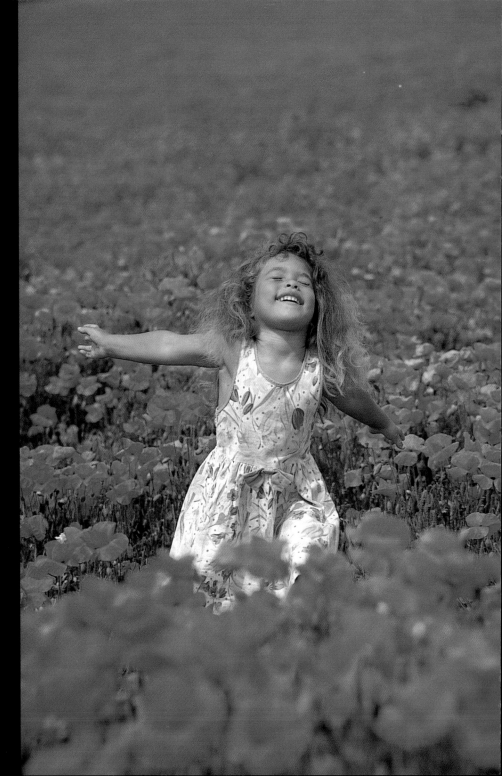

right > Using a long lens caused the flowers in the foreground and background blur for an eye-catching effect. They add color and interest to the shot without detracting from the focal point.

Automatic cameras select a depth of field for you when you select the shooting mode, or use the autofocus lock button. Portrait mode will select a narrow depth of field, and landscape mode will select a wide depth of field. On an SLR camera, you need to change the f-stops (which open and close the aperture) to set the depth of field.

Understanding and using depth of field allows you to have creative control over your pictures. For example, when the main subject is in focus against a blurred background, it has immediate impact and enables us to feel close to it. Artists have to create this by using tones; the dark tones appear nearest to us, the lighter ones further away.

Decide what your main subject is to be and isolate it by throwing the rest of the picture out of focus—or getting close enough to exclude most of the background altogether. You should only leave your background in focus if it has a relationship to the person or people in your picture—wonderful scenery on holiday, for example.

ask yourself ?

- Where is my main subject?
- Is my camera set to focus on my main subject?
- Do I need to include the background?

below > **A wide-angle lens will give you more depth of field than a longer one. Use it to keep the whole picture in focus when you want to show the person or people in their surroundings.**

positioning the subject

Where you place your subject in a photo is the key to creating balance. Nothing looks worse than a person who appears to be sinking out of the bottom of the frame. The 'bull's eye' position is also best avoided as it looks static and unimaginative. Instead, lock the focus on the subject by pressing the shutter halfway down, then move the camera to find a more striking composition before pressing the shutter all the way down.

The eyes are the most expressive part of a person, and need special consideration. If someone is looking at the camera, there will be eye contact with the viewer. If they are looking away from the camera, we will follow their line of gaze, so they need space to look into. Always place them looking into the picture, never out of it.

the rule of thirds

There's a rule of practice which demands that you divide your picture into three parts, like a noughts-and-crosses grid, made up of two horizontal and two vertical lines with four points of intersection. This grid dictates the 'rule of thirds'. If you compose your picture so that the main part of your subject is on a point, it's guaranteed to give a good result.

If you place a single person in the center of your frame, face on, it should look fine, as long as you position their eyes on the top grid line and their shoulders in the bottom third of the image. For a more interesting composition, place the person in the right or left third so that they have space at the side of them. You can then ask them to incline their head into this space, or they can lean inward to look at something.

ask yourself ?

■ Is my subject placed according to the rule of thirds?

■ Does my subject look like she is moving into the frame, or walking out of it?

■ Is there a horizontal, vertical, or diagonal line in my picture?

right > **Placing the subject so her head and eyes are to one side of the frame gives her space to look into and forces us to follow the line of her gaze.**

far right > **The little girl's eyes are the most important part of this picture, so they are placed close to the top left-hand 'point' according to the rule of thirds. It makes the composition more interesting than if she were bang in the middle of the picture.**

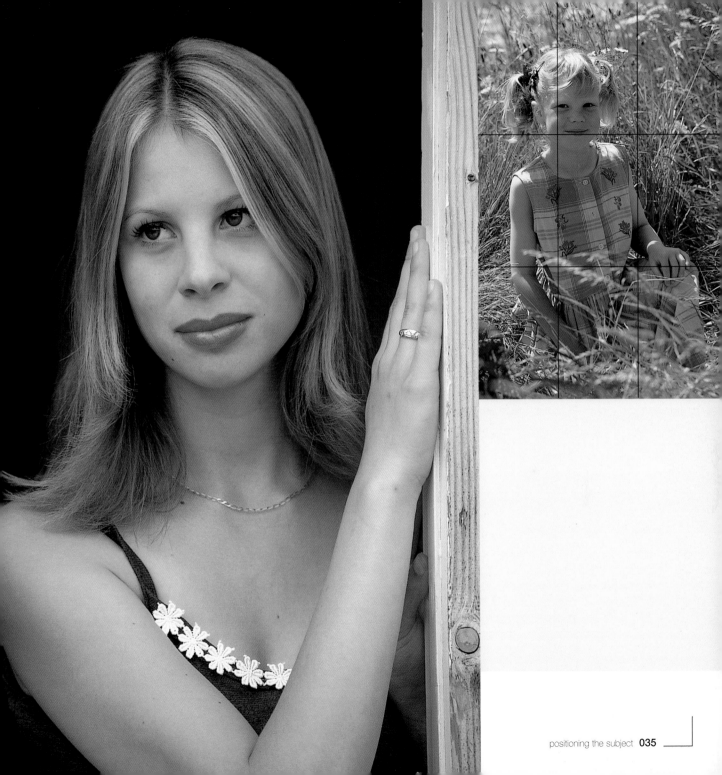

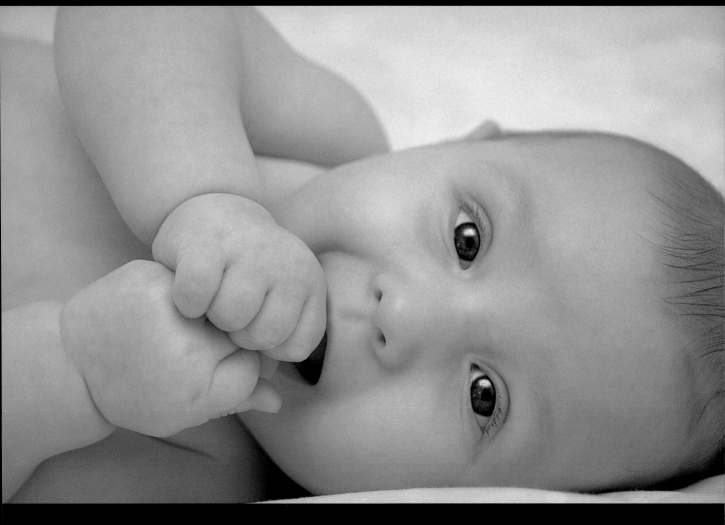

above > **The horizontal line of the form of this baby gives a**

above right > **Look for diagonal lines, or invent them,**

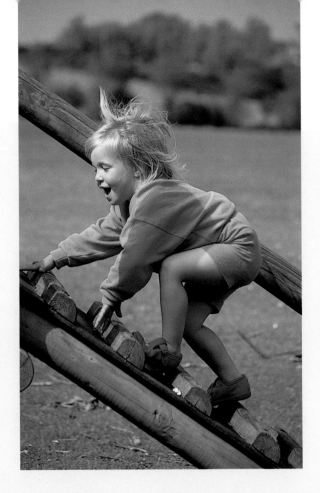

ideas to try

Choose a location with an interesting background, maybe to support your relative's hobby, such as a race track or football field:

1 Hold the camera horizontally and place the person in the middle foreground. Now recompose so that they are to one side, with the background occupying the other two-thirds.

2 Fill the frame with the person's head and shoulders, face on and looking at the camera.

3 Turn them sideways and position them in the right third of the picture, looking out of the frame. Keep them in the same part of the viewfinder and ask them to turn in the opposite direction, looking into the picture.

As well as horizontal and vertical lines, any directional lines can be used to create impact within the rule of thirds grid. Lines give a sense of direction and generate mood. They lead us into and through a picture and stop our eyes wandering out of it. Lines can be present in the picture, such as the side of a building or a pathway, or they can be created by the way you pose your subject.

Horizontal lines indicate calmness, peace, and quiet *(e.g. a baby lying sleeping).*
Vertical lines are more active than horizontal. They indicate strength and power *(e.g. a tall man).*
Curved lines create sensuality, softer feelings *(e.g. a woman's curves).*
Diagonal lines give a feeling of movement, energy, and action *(e.g. an athlete).*

posing

The secret of a successful portrait lies in a relaxed pose. It's tempting to force people to look straight at the camera in a very formal way and say 'cheese'. Mug shots are dull and unflattering. Who likes their passport photo?

Many people lack confidence in front of a camera and need to be put at ease. If there's more than one subject, encourage them to talk among themselves until you're ready to press the shutter.

Above all, try to make the occasion fun and avoid tension. At first you may find it strange trying to direct your subject into a pose, but it's worth taking time over it. Unless they're models, people don't present their most flattering aspect to the camera and they'll appreciate the results of a little care.

ask yourself ?

- Does the person look relaxed and comfortable?
- Do their legs and feet, arms and hands look harmonious?
- Does my picture form an aesthetic shape such as a diagonal or triangle?

below > A good rule is to consider the triangle because it makes a pleasing composition. The middle person should be a little higher than those on either side, with equal space between. In this shot, the diagonal line-up works well. The arms of the dad and the boy add to the triangular element.

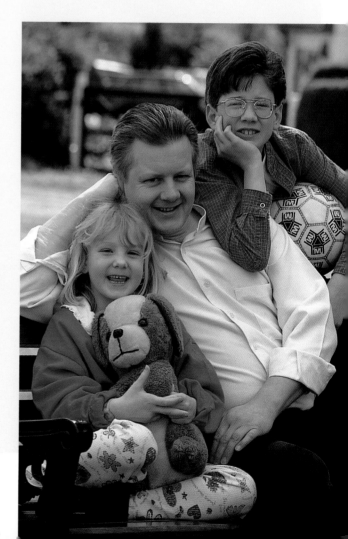

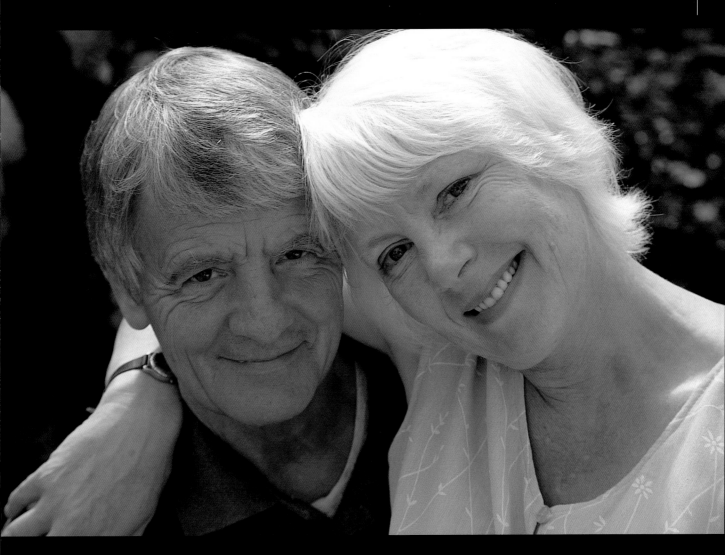

above > Posing a couple is easier than arranging large groups. Two people standing side by side should incline their heads, or face each other, or stand back to back, but rarely stand head-on to the camera . Try placing him in the foreground with his partner slightly behind, her arms round his shoulders and leaning towards him. They could be looking at one another. Some couples are uncomfortable looking into each other's eyes while some find it natural.

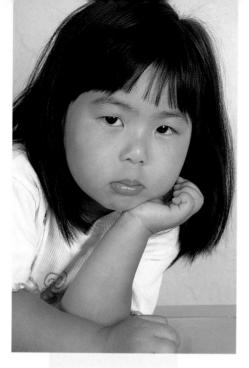

above left > Notice how this little girl is leaning slightly into the picture. Placing the chin on the hand gives a thoughtful-looking pose and helps to keep the head steady.

above right > A good pose is to position your subject with the body at a 45° angle to the camera as diagonal lines have the best impact. Eyes should be in the top third of the frame.

posing single people

It's vital that you consider the shape created by the figure and how it works within the composition. Be conscious of every element: the position of the head and shoulders, hands and arms, legs and feet. Never 'cut off' at joints: sever from above the knee rather than below, and above the waist rather than on it. And don't amputate your subject's head.

Most people are self-conscious about something so don't exaggerate it. A double chin can be minimized by raising the face. Bad posture shows in a picture: the shoulders sag, the back hunches, and the belly sticks out. Holding the pelvis in and pressing the shoulders back creates a confident look.

Single portraits are usually taken with the camera in an upright position, with a horizontal shot saved for a group shot. You can opt for a full-length portrait, a three-quarter pose, head and shoulders, or a close-up of the head. A zoom lens will enable you to try out all of these. Close-ups are more intimate, and reveal most about a subject.

standing poses

Because a person occupies only one-third of the viewfinder when they're standing, make sure the space is used in a balanced way. A man can stand with his hands in his pockets or his arms folded. A woman will look more graceful with one hand on her hip and the other on her thigh, or with the weight on one leg and the other at a slight angle, bent at the knee.

People look more comfortable if they are leaning on something rather than standing alone—a doorway, a gate, a tree, a chair—anything within your surroundings. Maybe they're especially proud of something, such as a car, which you can prop them up against.

Try out different ideas. A child photographed from behind can be endearing, or maybe walking down the street under an umbrella, or carrying a teddy bear.

right > A tree can provide an ideal prop for someone to lean against, which looks more relaxed than if they're standing alone. Make sure their body is at a slight angle to the tree rather than bolt upright next to it.

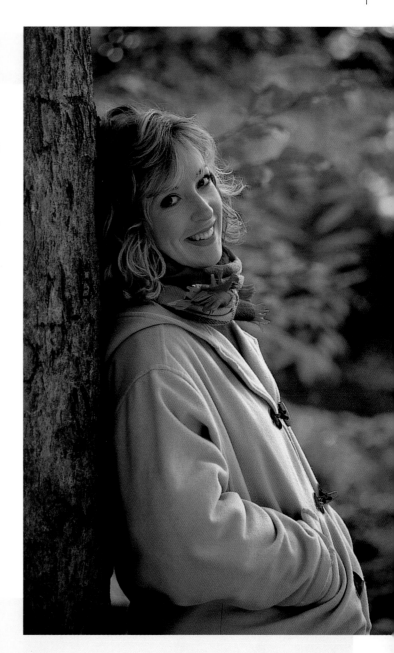

below > **Even with the most relaxed and informal portraits, you can still make a big difference to the look of the picture with minor adjustments to the pose. Here the man's tilting head forms a pleasing triangular shape with his arm. The newspaper and cup of coffee set the scene and provide him with a prop to hold.**

right > **Placing two people's heads close together will ensure they are both in focus, and it's appropriate for good friends as well as couples. The arm and hand of the girl on the right forms a kind of triangular frame here, drawing them together in a natural-looking way.**

sitting poses

It's much easier to fill the frame with sitting poses. They're especially useful for very tall members of the family but most people feel relaxed sitting on a chair, on some steps, at a table where they can rest their elbows, or on the floor where they can put their knees up. Head and shoulder portraits look best when the subject is sitting sideways and turning the body towards the camera, rather than face on. Be careful not to turn the head so much that the neck wrinkles. For a lively look, a woman or girl can sit or stand with her back to you and swivel at the waist as you fire the shutter to the swing of her hair.

hands and arms

These can be tricky as not everyone has photogenic hands. Fingers should not be linked like sausages. Ask the person to hold something, or to bend their fingers. Resting one hand on top of the other looks neat, too. Only include hands near the face if they're dainty or if they say something about the character of a person— the lines and wrinkles of an old lady, for example.

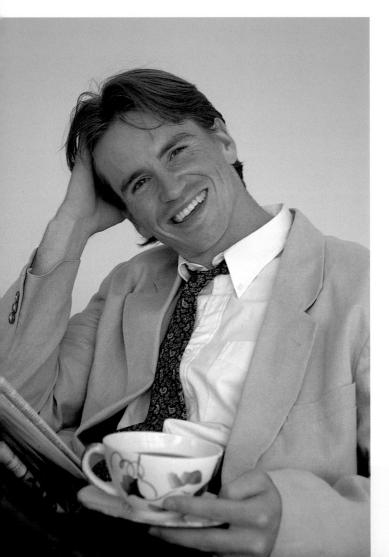

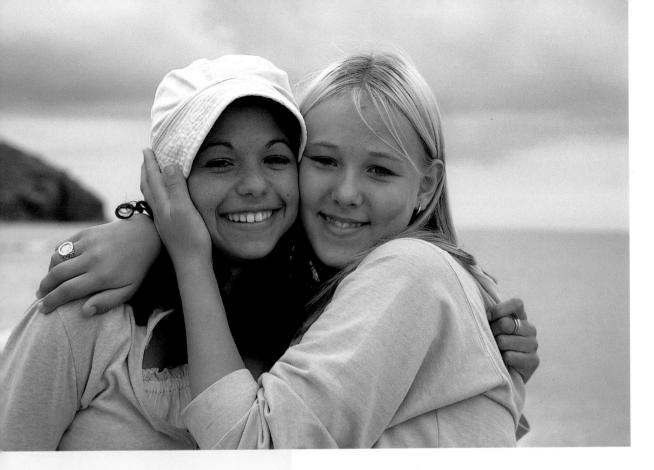

posing two people

Posing a pair is harder than individuals because the eye has to take in two faces, and their expressions should be complementary. Fill the viewfinder with them, making sure there's no vacant space in between, which will cause an autofocus camera to focus behind them. The viewer's eye will be directed straight through the space.

Two people side-by-side look better if they incline their heads, face each other, or stand back to back, but not head on. Inclining heads form a nice triangular shape and encourage a sense of belonging.

A double portrait looks more interesting if the pair is interacting. Kids do this naturally if given a game to play. They tend to be uninhibited about being put close together. Facing you, they can play up to the camera badly and the picture looks horribly posed. Encourage them to at least put their arms around each other.

groups of three or more

Things get complicated when eyes wander all over the place. Professionals have tactics to make sure a group pays attention—one famous snapper carries a whistle with him! Take lots of pictures to ensure that everyone looks happy.

To pose three people, arrange them in a triangle or on a diagonal line. The triangle can be achieved by sitting one person in a chair and the others on the floor, or by seating one person in a chair and others behind. Space between individuals should be equal. If there's too large a gap the eye is led through and behind the group, too small a gap and they might cast shadows on each other. Again, for a more natural shot, have them interact with each other.

With larger groups, you can play around with poses. Vary the angles of their bodies, keeping their arms and legs tidy. To provide a focal point, all members need to be looking at the same spot—perhaps a grandchild at the pinnacle of the triangle. If someone is looking out of the frame, the impact will be lost.

Another way of grouping large numbers is to use a theme, perhaps something like your son's soccer strip and a football to cohere the unit. Kids can also be grouped by using an unusual camera angle.

ideas to try

Ask a family member to stand outside under a tree or against a post in the following positions:

1 Facing you, arms hanging by their side, slouched

2 Standing sideways, with his or her back leaning against the support, hands in pockets. Stand in front of the person and have them turn their head towards the camera

Sit another willing volunteer in a chair:

1 Facing you, legs straight, hands clasped. Look through the viewfinder

2 Turn the chair sideways. Get them to keep their torso where it is, but turn their head and shoulders to the camera, arms resting on the back of the chair. Which looks more relaxed?

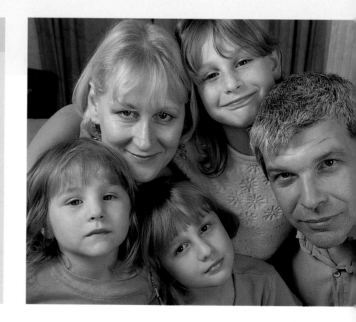

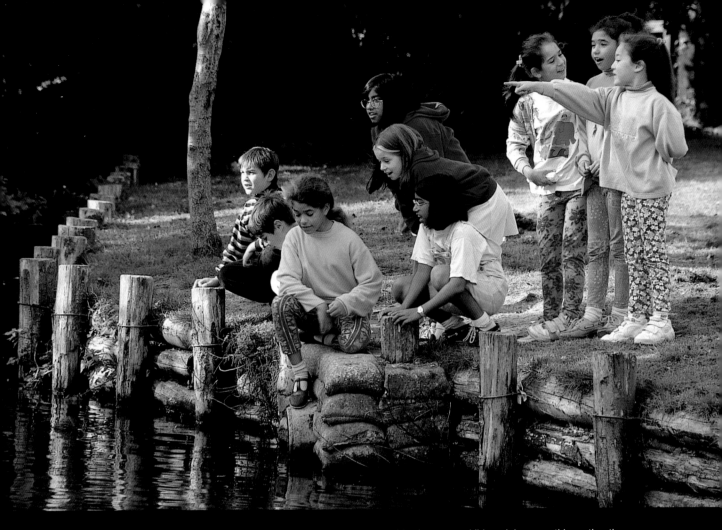

left > Family members need to be linked in some way, so have their heads inclined towards each other, or have them linking arms or hugging each other. Creating a triangle is always good for a successful group pose.

above > It's nice to see children doing something rather than standing like soldiers. You may need some help arranging them, while you call out instructions and check the pose through the camera. Giving them something to look at will ensure that most eyes are in the same direction. Vary the levels and angles of their bodies with some standing, and others sitting or crouching.

framing the subject

Try to frame your subjects while they're in the viewfinder. Using a border makes a picture coherent and helps to lead your viewer's eye to the focal point, adding impact. Frames are also good for disguising plain backgrounds, such as a dull sky, or hiding distracting details. Indoors, doors and windows are obvious frames. When you look through the viewfinder, make sure the edges of the doorway, and so on, are parallel to those of your viewfinder.

Buildings, especially historic ones, are full of tailor-made frames. Archways provide an attractive curve over people. Overhanging branches form nice natural frames. Silhouettes are striking, too. A silhouetted border happens when you are shooting through a dark interior into light.

Experiment with your frame, and use your viewfinder to crop the image around the subject. You can do this by using a zoom lens, or moving in closer. Take care that the frame is not so overpowering that it steals attention from the person you are photographing, and that it looks appropriate for the subject.

Foregrounds and backgrounds can be used to frame your image—a person surrounded by a field of flowers, for example. One part of the foreground should continue round into the background, or the other way around.

ask yourself

- Are there any features around that could work as a frame?
- Will it look better if you change position or zoom in or out?
- Does the frame draw attention to, or detract from, the subject? The frame should be darker.
- Does it involve part of the scene that enhances the picture?
- Is it natural, artistic, or a replica of the camera's viewfinder?

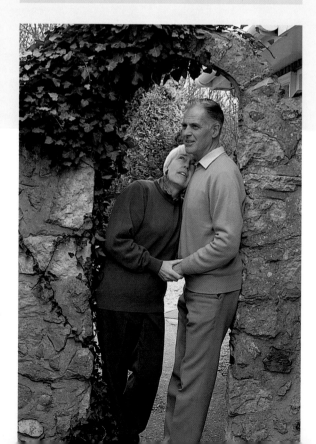

right > Archways are ideal for framing people. This is an example of a situation where it offers a pleasing symmetry.

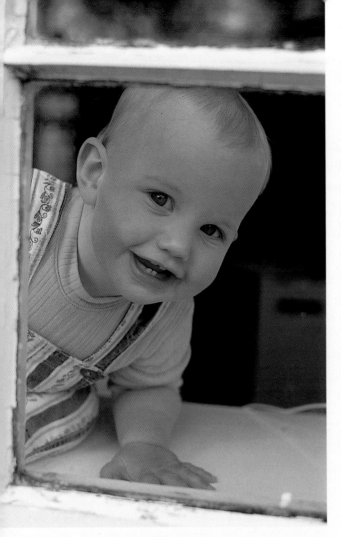

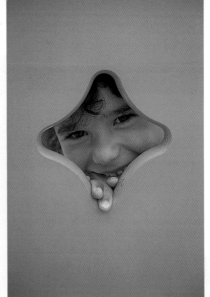

ideas to try

1 Choose a doorway inside in which to stand your subject full length. Turning the camera vertically, use the doorway to create a border around them.

2 Find some foliage that creates an archway or border. Ask your subject to sit in the opening and view them through your wideangle lens. Next crop in really tight, filling the edges of your viewfinder. Try this horizontally and vertically.

top left > Babies and toddlers love to play peekaboo and you can take advantage by finding a door or window to act as your frame and then encouraging them into position by starting a game.

top right > A visit to a local park or playground will be full of structures you can use for framing the kids. Children are naturally curious when it comes to peering in and out of windows and climbing frames, so you're bound to get a spirited photo somewhere as the child finds an opening to peek through.

camera angles

For a view of a valley, you must be at the top of the hill. The best view of a skyscraper is from the bottom looking up. Similarly, when photographing people your viewpoint can alter the feel of the subject.

Most people hold the camera at eye level producing a boring perspective. It's okay to move the camera! Turn it vertically, horizontally, diagonally, hold it above or below the subject, and see how it varies the impact. Use a wide-angle lens close up to exaggerate effects, or create dynamic shots by lying on the ground pointing the camera upward to capture your child springing off a skateboard ramp, or leaping into midair off a wall.

choosing your angle

Shoot at the subject's level, not your own. On the same level as your subject, for example lying on your tummy to photograph a baby or child, signifies equality. You're seeing the world through their eyes. Standing above your subject and looking down makes you look big and it small. A little child looking wide-eyed up at the camera can be very appealing. Looking down at someone rock climbing gives a sense of their ambition: their aim is to get to the top. Standing below your subject and looking up signifies the opposite. This angle produces a very strong, sometimes menacing, portrait.

ideas to try

Ask a child to sit cross-legged in the garden and take pictures of him:

1 using your widest angle and, with the camera vertical, looking down at him. Do the same with a longer lens

2 sitting in front of the child at the same level

3 lying on your tummy with the child standing in front of you

4 lying on your back with the child standing, peering down at the camera

right > Getting children to form a circle, looking down on you as you lie on the ground, is a fun way of taking a group shot. If their faces are too much in shadow, you may need to use fill-in flash or place white material on the ground around you to reflect the light back up.

far right > Tilting the camera can work wonders for a lively action shot. The diagonal horizon forms a graphic triangle of green in the background and echoes the outstretched arms of the girl.

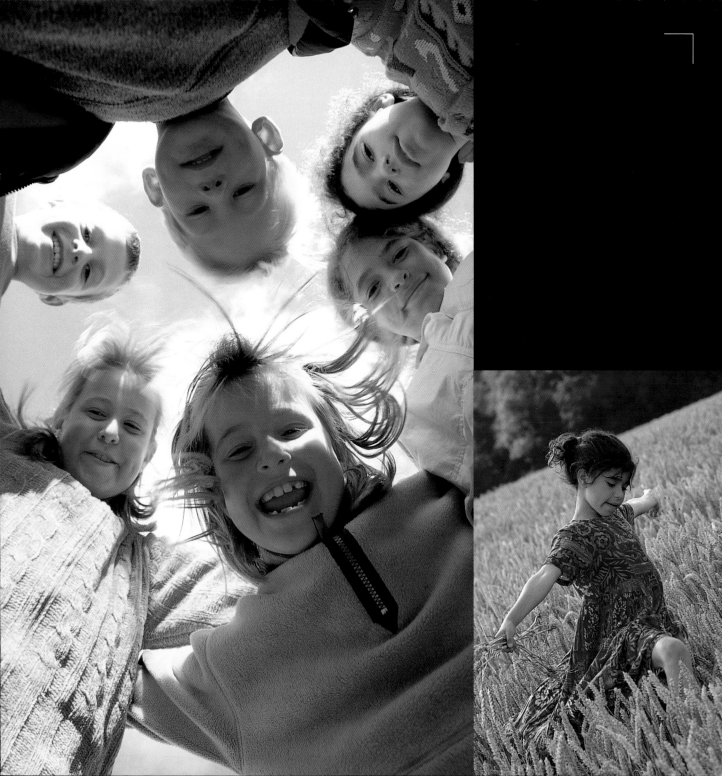

color and props

color

Quite apart from shaping your pictures through poses and directional lines, there are occasions when they need an extra lift, maybe because they lack something, or need a splash of color.

Any change you make through your viewfinder will affect the final mood. A baby dressed in primary colors will look more vibrant and lively than one dressed in pastels, although the latter might suit a softer mood. Flip through some magazines and see how color is used in advertising. Contrasting colors like yellow and blue, as well as strong shapes, are sure ways of grabbing your attention.

Color can be used in quite a subtle way to link the subject to the surroundings. The color of flowers in a meadow can be used to pick out colors in a little girl's dress, or the little girl's dress can be chosen to pick out the flowers in the meadow!

Be careful when you include red. It's the most eye-catching color and wherever you put it in the picture it will attract attention. That's fine if your subject is wearing it or holding something red, but not if you've accidentally forgotten about the party balloon in the background. Any colorful props you include must create balance within the picture and not lead the eye out of the frame.

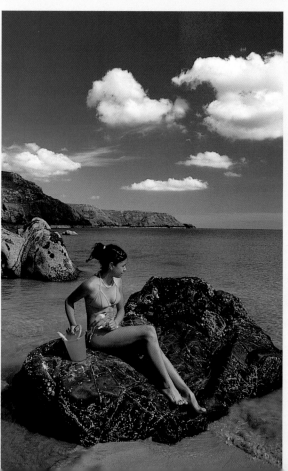

ask yourself

- How can I improve the balance in my picture? Is there a space that needs filling?

- Would a splash of color enhance my picture?

- Could I improve my picture by introducing a prop?

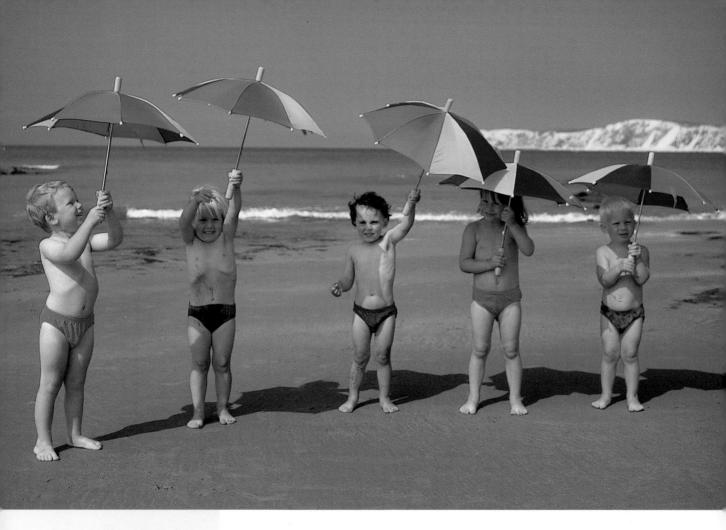

left > In scenes where all the tones are fairly similar, a splash of color can give the picture a real lift. Here, the girl's blue bikini and bright pink pail draw the eye's attention and brighten up the image.

above > These bright little umbrellas help to make this a really eye-catching, colorful shot. They also work well as props, giving the toddlers something fun to do, and linking them all together to bring unity to the group.

right > The flowers work well as a prop to enhance the pose. They also add interest to the composition and a splash of color, contrasting with the muted tones elsewhere.

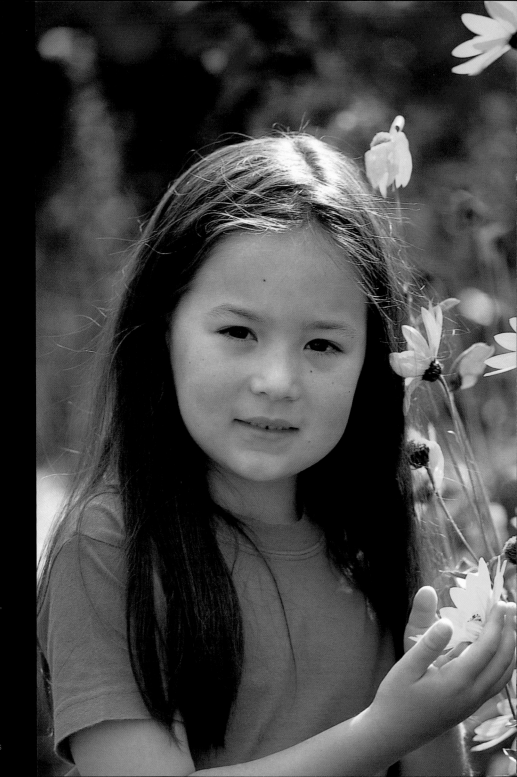

1 Sit a family member against a plain background, holding the camera horizontally to open up a vacant space beside them

2 Introduce props into the space; look around the room for inspiration and start with neutral colors, then add a vibrant green plant, and then one in flower, for example. Notice the difference. Try this with your camera in the vertical format

3 Pose your model in one of the poses described in the section on posing. Now give them something to hold

4 Take a child or adult outside on a wet day. Add a bright umbrella and see how the mood changes

right > **As well as adding to the composition and describing a personality, props are invaluable for achieving a natural pose. Most people feel much more comfortable holding something.**

props

A prop can be anything. It can be a background, a chair, a plant—anything. Toys make useful props for kids. Where possible, make the prop relevant to the person in your picture, so that it reveals something about them. An artist is fine standing beside his painting, but holding a palette and brush would tell us that he had done that painting. The latest star of the school football team needs to hold a ball, a medal, or cup. A prop can be used to create interesting foregrounds: a bowl of fruit, a bed of flowers, a train set. It can also be a symbol, such as a wedding ring.

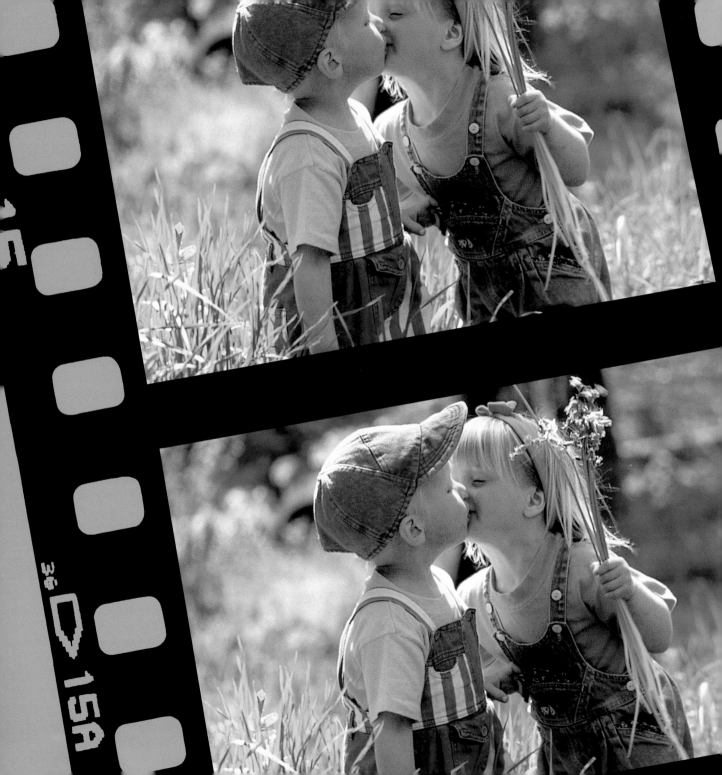

lighting

3

brightness, color, quality

Lighting is vital to a successful picture; it can bring it alive or ruin it. We've all been snapped on vacation under a midday sun, and no-one likes the result. Harsh lighting ages us and makes us squint. Fortunately, there are alternatives!

Light has three properties: brightness, color, and quality. The size of the light source, and its position, will also have an effect on the mood of the picture. Various terms describe lighting: harsh, soft, diffused, flat, direct, and indirect.

Outside, the color of the light changes with the season and weather. To understand how this affects your photos, take pictures at different times of day, all year round, in all sorts of weather, with and without flash. You can control the light by changing location, moving the angle of your viewfinder or the position of your subjects, so that the light falling on them brings out their attributes.

ask yourself ?

- Which direction is the light coming from and where is it falling on the subject?
- Where are the highlights and shadows?
- Is this the most flattering light?

right > The direction of the light in this picture adds an attractive glow to the father and his little baby. Backlighting is a great effect for producing this kind of charming portrait.

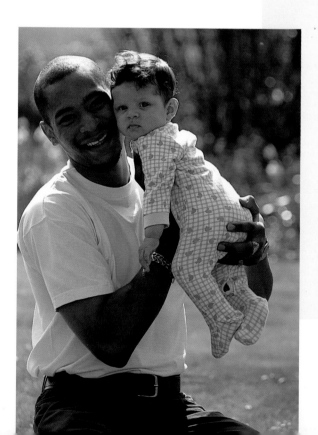

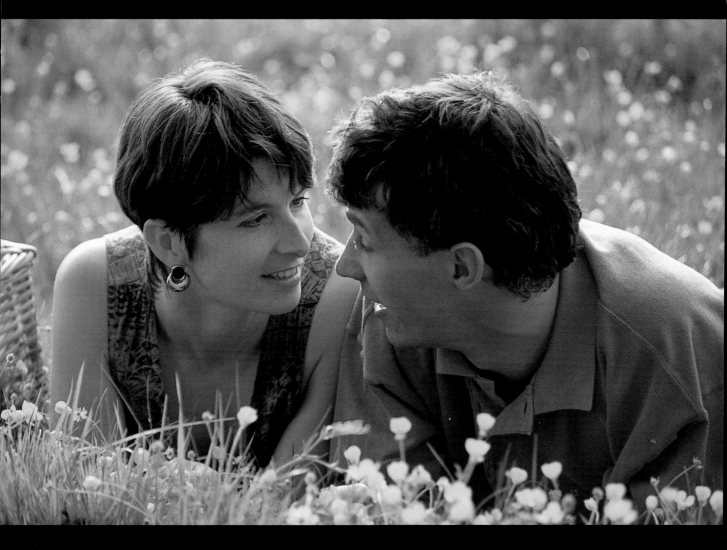

above > The late afternoon or early evening of a sunny day is much favored by portrait photographers because the light has a wonderful warm glow. Here it is accentuated by the reflection of the yellow flowers on the couple's faces.

outdoor light

There's no better light source for family pictures than natural light. Light falls on your subject either directly or indirectly. Direct light comes from three directions. It is important to know where these are, since each produces its own effect.

front lighting

This is when the sun is behind you and the light falls directly on your subject's face. Shooting with the sun behind your left shoulder is often advised, but is a mistake for portraits, since intense directional light isn't attractive. Contrast between light and dark areas is stronger, shadows appear around the eyes and nose, and unsightly detail is picked up.

We tend to take lots of our pictures around midday, but by evening when the sun is low in the sky, the light is more flattering. It's like the difference between a bare 150 watt light bulb overhead and a 60 watt lamp in a corner.

backlighting

Also known as *contre-jour*, backlighting occurs when you are facing the sun and the light is falling behind the subject so that the face is obscured from direct light and only its rim is lit, creating a halo around the head. It tends to arouse strong emotional responses and is ideal for children and women, softening skin tones and any stress lines.

Shooting directly into the sun can cause lens flare. Try tilting the camera down to avoid this. Or keep the sun out of the lens by casting a shadow over it with your hand. You may need to use fill-in flash to balance the light falling on the subject with that of the strong background. Holding up a reflector of some kind in front of the subject will have the same effect.

side lighting

This arrives early or late in the day when the sun is not overhead. It is, literally, light falling onto the side of the subject. One side will be well lit, the other in shadow, which can create mood. Side lighting accentuates bone structure and shows up skin texture. If you don't want the other side of the face to be dark, lighten it with a reflector to fill in the shadow.

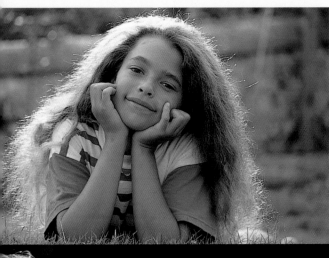

left > Backlighting gives an angelic effect. You have to watch out, though, because the camera's metering can be fooled by bright sunshine and throw your subject into silhouette.

below > This child's face and her toy are gently lit from behind and one side by the sun as she reads him a story. It's a very gentle effect that is really evocative of childhood.

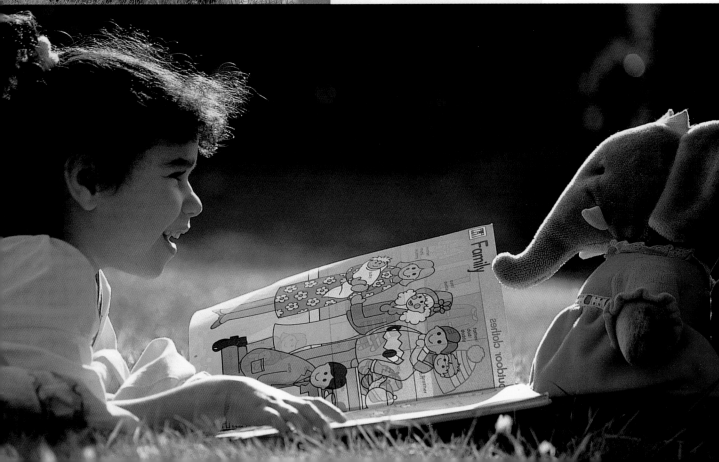

below > Direct sun in front of the subject causes unattractive shadows under the chin and eyes.

below right > Just a short while later, the sun was obscured by a cloud. The result is much more even; diffuse lighting with no unwanted shadows.

far right > This is a nice example of diffuse lighting on the mother and daughter. It gives it a soft, intimate feel.

indirect lighting

Indirect light means that the rays of the sun are not falling directly onto the subject, but are blocked, diffused, or reflected in some way.

open shade

This is when the light is falling somewhere other than on the subject who is in light shade, perhaps in the shadow cast by a building. There is still plenty of light filtering from outside into the shaded area.

Placing your subjects in the shade is more comfortable for them than direct sun and produces more flattering portraits. There won't be any hot spots on the face and skin tones will look natural. Colors will have subtle variations, though may be a little cool in tone.

diffused light

This is when the direct light source has been toned down or scattered, either by putting the subject in open shade or by adding something between the light source and the person. Just put your hand under a light bulb, then place a piece of white tissue between the light bulb and your hand. Notice how much softer the light becomes.

Diffused light is also created by a hazy atmosphere or on overcast days. This can be imitated by placing a soft focus or fog filter over the lens, but far better to use the real thing. Fog and mist will reduce light intake, so make sure you set up a tripod in subdued conditions, or use fast film.

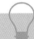

ideas to try

Pose a family member outside on a clear, sunny day:

1 with the sun behind you, i.e. in front of your subject

2 with the sun behind your subject, i.e. in front of you

3 with the sun at the side of your subject (this will be early morning or late afternoon)

4 in open shade, i.e. any area blocking the sun surrounding it. You don't have to be standing in the shade

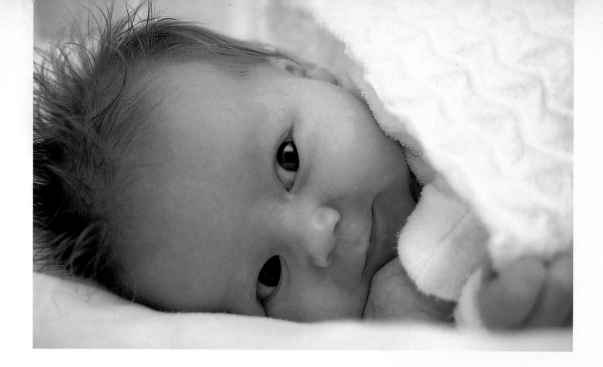

indoor light

It's easy to fire away with a camera and a flash. But natural light from a window has a much nicer effect, and helps to define the face. Picture windows are ideal because they are large and give a wide light source. Skylights are useful, too.

using windows

The window can be open or closed but extremes of brightness should be avoided. If the sun is streaming through the window onto your subject, you'll have too much contrast, and your subject's eyes will be screwed up. Wait until the sun moves, cover the window with tracing paper or a lace drape, or move to another window. Err on the side of caution when shooting indoors without flash, and support your camera on a tripod.

Be aware of the direction of your light source even when using a window. The closer your subject is to the window, the stronger and more directional the light. The further away, the weaker and more diffuse the light. If you have your back to the window and your subject faces you, he'll also be more evenly lit. Fill in shadow with a reflector.

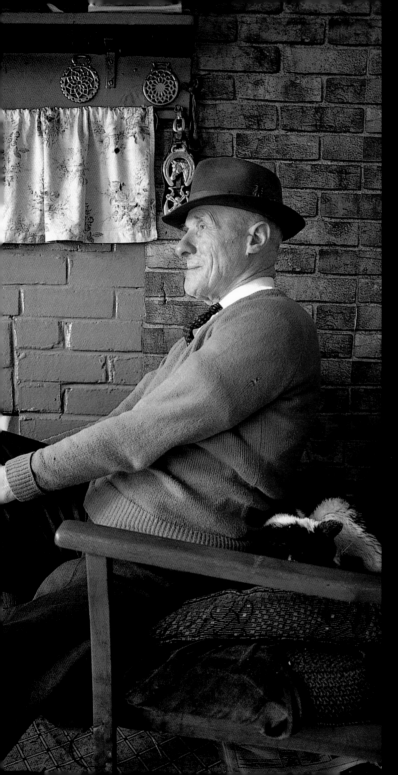

far left > Indoors, light from a
window is much softer and more natural
than flash. Here it was behind the
photographer and in front of the baby.
Use a faster film than you would need
outside to cope with the lower light,
and support the camera on a tripod,
if possible, to avoid camera shake during
a long exposure.

left > A window in front of the man
and at a 90° angle to the camera provided
even lighting, and allowed the glow of the
fire to record naturally. Flash produces
much starker results and the warm feel of
the shot would have been lost.

If you're including an area of window in your picture, exposure calculations can be a little tricky. Your camera may think it's brighter than it actually is and the picture will turn out too dark. Get round this by focusing on a mid-tone area (by pressing the shutter halfway down) before recomposing to take the picture. SLR users can overexpose by one or two f-stops. In scenes where the indoor and outdoor light is fairly even, your camera should expose correctly.

household lighting

When shooting indoors, you need film balanced for the light source you're using. With natural light, the usual daylight film is fine. Turn off household bulbs or you'll get orange color casts. If you want to shoot under domestic lighting, you'll need to get special film color-balanced for artificial light, called tungsten film. This is generally only available in camera stores.

There's no film balanced for fluorescent lighting so it's best to avoid this. Fluorescent lights give a green tinge to your pictures and the only way to correct this (and not fully) is to add a FLD (daylight-type fluorescent light) filter, only available for SLR cameras.

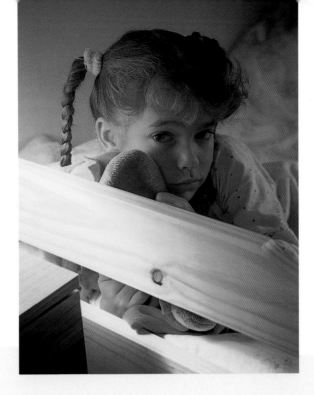

above > The orange color cast of household bulbs is often best avoided by using tungsten-balanced film, although it can add to the warm and cosy atmosphere of bedtime.

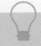

ideas to try

Choose a room in your house with plenty of natural light. Pose a family member:

1 right by the window, looking out

2 with his or her back to the window, looking at you

3 away from the window, facing you, and with your back to it

4 Do the same thing using a white sheet, sheet of aluminum foil or newspaper to reflect light into the shadows

far left > If the girls had been photographed further into the store, the fluorescent lighting would have caused a nasty green color cast. Because they were near to the door, there was enough natural light coming from the street to avoid this.

using flash

Your child is performing in a play. You're snapping away and—hey presto!—the pictures come back black except for the heads of the people in front of you. What happened to the moments you tried to capture?

You can't expect the same effect from a tiny flash bulb in a compact camera as from flash units in a professional studio. There's a limit to how far you can go with your flash unit, so check its distance in your camera's manual.

Even basic cameras have a built-in flash integrated into the camera's metering system. The exposure is calculated for you because the flash exposure meter balances with normal lighting. However, the light quality can be unflattering.

The people in your photo should not be too close to the flash or they'll be overpowered by it. They should not stand too near a wall or shadows will be cast onto the background. When posing groups, make sure they're all positioned at the same distance from the lens. Just like a torch, light fall-off occurs as distance increases, so the ones furthest away from you will be underexposed and, too far away out of flash range, they'll be in total darkness.

ideas to try

Take a picture of a family member or group:

1 outside on a dark evening using flash on full power

2 outside around lots of ambient light with fill-in flash

3 outside on a dull day with a bit of fill-in flash

4 outside with the sun behind them, first with no flash, then with fill-in flash, and lastly, without flash, and using a reflector

5 indoors leaning against a wall with flash on full power, then standing 4ft (1.2m) from the wall with flash on full power

6 indoors during the day with the drapes closed and full flash, then with the drapes open and using fill-in flash

far right > **The small flashguns on compact cameras are not powerful enough to light up a whole room. They will pick up areas of the scene that are giving off the most light, like bits of white paper on the floor and lightbulbs, putting the rest of the background in darkness.**

right > **This is a much better result. Most of the lighting comes from windows but the camera was set to fill-in flash mode to brighten up the picture and eliminate shadows.**

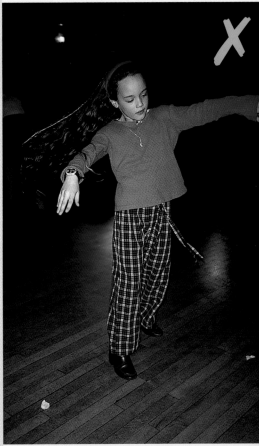

The best way to use on-camera flash is to keep it to a minimum, don't include too much in the picture and try to preserve as much natural light as possible. As daylight fades the need for flash increases, so that it becomes your main light source. At this stage, it will cancel out any other ambient light, and becomes too overpowering. When the flash is more powerful than other light sources around it, your pictures begin to look unnatural.

Flash isn't all bad news, though. It's useful when low light needs a boost. Used with fast film (which requires less flash), it can supplement outdoor evening light, add a bit of sparkle to colors on dull days, or freeze action if someone is moving. Fires should record as a warm glow. When you're shooting under tungsten lights indoors and want to retain a bit of ambience but avoid orange color casts, put the lights on and use a short burst of flash.

Be careful where you angle your camera when using flash. If you're taking a portrait, don't fire from a low angle or your subject will look like a character in a horror movie. Stand slightly to one side of them and put a white reflector on the other so that light reflects back. They'll be lit more evenly this way.

right > Outdoors, fill-in flash is useful to balance the light when the sun is behind the subject. You still retain all the nice effects of backlighting but it will reduce the shadow areas on their faces and bodies. Try it on dull days, too, to add a bit of sparkle to colors and warm up the cool tones of a cloudy sky.

bottom right > Most compact and SLR cameras have a fill-in flash mode, which means that the flash will fire automatically, even if there is plenty of available light. Use this outdoors to freeze the movement of action shots. The lighting will still look natural because the daylight will be dominant.

avoiding problems with flash

- On-camera flash won't offer ideal modelling light. It deadens pictures, giving portraits a flat, two-dimensional look.
- Dark shadows are cast when you put the subject too close to the background. Best pose them a little way back, but not too far so that the background turns black.
- Red-eye happens with direct flash because the flash unit is too close to the lens. It tends to be worse in dimly lit situations when the pupils are most dilated. Red-eye reduction facilities on cameras help to reduce this but not totally resolve it. They work by giving a burst of light prior to exposure to prepare the pupils for the 'real' flash.
- Shiny reflective surfaces are highlighted with flash and create hot spots in pictures, distracting the eye from the main subject. Move any items out of the way. Windows reflect flash so avoid placing subjects in front of them.

below right > An SLR offers you a wider range of effects with more powerful flash units. A flashgun means you can turn the unit upwards and bounce light from a white ceiling, lighting your subject evenly. It must be white otherwise your subject will take on its color cast. It's also possible to purchase a cable that enables you to use your flash unit off-camera.

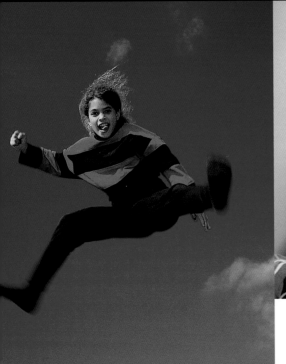

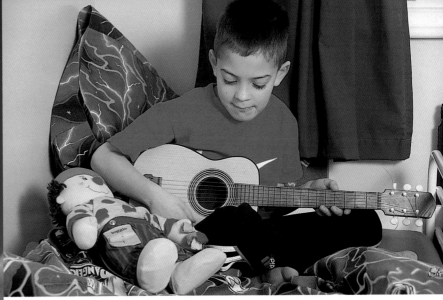

family subjects

4

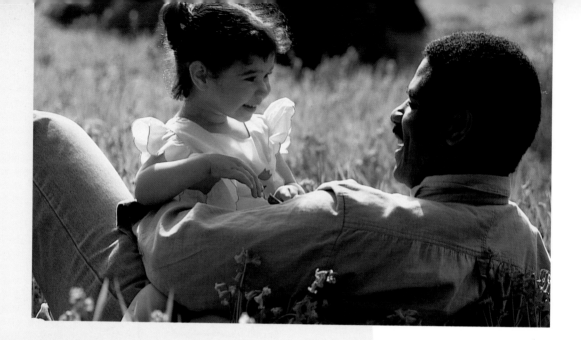

family ties

At sometime in our childhood we've all been placed, often unwillingly, in front of the camera and asked to produce a smile. Whether we loved or hated it, most of us have great fun digging out old photos and reminiscing about when we were young. If you're lucky enough to own old photographs of your ancestors, the chances are that you'll get emotional when you look at those, too. They have a romantic quality, reinforcing our heritage and family ties. We get personally attached to them and, moving house, we'd rather leave our furniture behind than cherished family photos.

The concept of family attachment hasn't gone out of fashion since cameras were invented. Still, the key to every successful picture is the relationship between its elements. When photographing the family, always think of intimacy rather than the distant approach you'd take if your subject were a stranger on the street.

Make sure you pose people in a unified way, whether it's a parent and child, siblings, grandparents, or a child with a pet. Even a child alone should form an invisible link with the photographer, who may be a parent or relative.

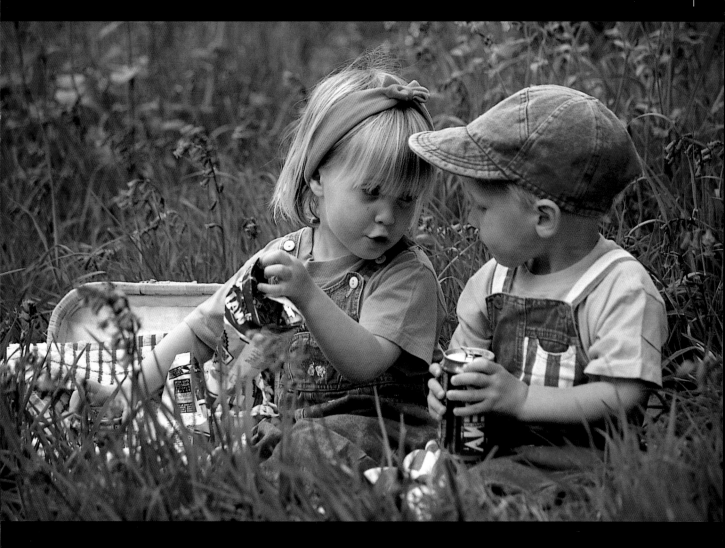

above left > Here the sun is behind and slightly to the left of the father and child, producing an attractive rim of light around them. When you're posing your subject, move them around until you can see where the light has the best effect.

above > The subjects don't have to be looking at the camera to make a successful picture. If you find an attractive setting and give small children a picnic to keep them busy, you can wait for the moment when there's some kind of

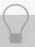

ideas to try

1 Design a comfortable set-up for your baby in window light using cushions and a plain sheet. Lie or sit your baby and have a squeaky toy to attract his or her attention

2 Take a tender portrait of a sleeping newborn lying on mom or dad's bare chest, cropping in closely. Black and white film works well for this

3 Introduce a toy and allow the baby to explore it. Capture his or her expressions through the viewfinder

4 Sit your baby in a highchair and provide some food. Get in close and record the mess he or she invariably makes

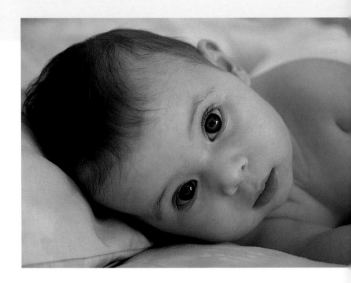

babies

From birth, practically every parent grabs the camera. In fact, more pictures are taken of babies than of any other subject. Such rapid changes occur during the first few months that it's natural to want to capture every moment. For a rewarding record, pay attention to lighting and composition, and take the time to plan a few simple set-ups. Babies' expressions are forever changing. Grab what happens naturally rather than try to coax a smile all the time.

above > **For formal shots of a little baby, a bed surrounded by pillows and covered in a plain sheet is a good setting. You can make a little nest among the cushions for a newborn while older babies can be propped up with pillows. Lighting should be as soft as possible. With a compact camera, try to** avoid flash; fast film (ISO 400) with natural light from a nearby window is preferable. SLR camera users can attach a flash unit and bounce the flash from a white ceiling, producing a portrait that looks like it's been taken in a studio.

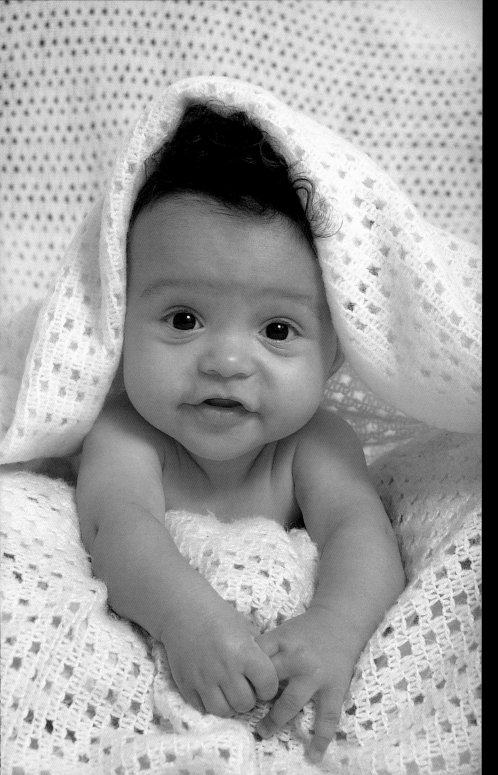

left > The simplest of props can be used for a really cute baby portrait. For this shot, a soft blanket was draped over the baby and the shutter pressed as he crawled out. Use a zoom lens to crop in tightly and make sure there are no distracting colors or objects in the background. Like the rest of us, babies soon tire of the camera and they'll make it quite clear when they've had enough. Don't expect to get posed pictures for more than ten minutes and try to make the session a game.

newborn babies

- Natural reflexes cause involuntary movements so this is a good time to capture changing expressions.
- Show the baby's vulnerability and fragility by supporting her head in a parent's hands.
- A sleeping baby will look serene photographed in his or her crib with natural light falling across them. Try to avoid direct flash.

six weeks on

- Don't miss the first smile—or the second or third!
- Create a spot on the bed and get down to the baby's level. Wrap the baby up in a blanket, or let him lie naked and wave arms and legs. See what happens.
- At this age a baby can follow a moving object, so have someone hold up a toy and move it from one side of the face to the other. Catch the baby's reaction.

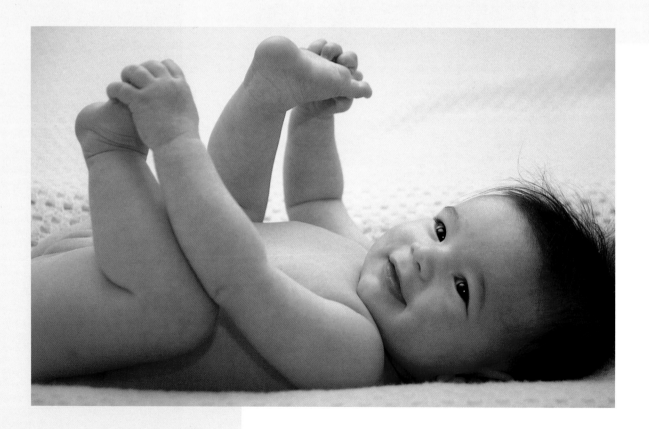

three to six months

- Hands and feet are a source of fascination. Take a picture as he sucks on fingers or reaches for toes.
- Now the baby can hold toys, introduce props in your photos, but don't let them mask your baby's face.
- Create a formal shot on a bed surrounded by pillows, covered in a pale sheet. Make a little nest with the pillows to prop the baby up.

six to twelve months

- Take a close up of your baby showing a first tooth.
- Bathtime shots are good fun—especially with a few rubber ducks and plenty of bubbles.
- Baby's on the move: crawling, cruising, and taking first steps. Get down on the floor to shoot at the baby's level.

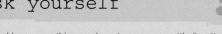

ask yourself

- Do I have everything ready: set-up, props, rattle (to attract attention), and camera?
- Is this the most attractive location and lighting for baby?
- Have I got down to baby's eye level?

left > **From three months, babies are more photogenic, smiling a lot, and fascinated by everything. Lie the baby on the floor, and photograph with a zoom lens to fill the frame.**

above > **After feeding, newborn babies tend to fall asleep, so a tender portrait can be obtained by lying baby on the mother's bare chest and cropping in close.**

children

Kids can make photography easy for you. As long as it's fun, and they don't feel under pressure, they'll usually be quite happy to play along to the camera—although maybe not for long. Whatever you do, don't force them into situations against their will or they'll dig in their heels, and you'll just end up with tense and tearful pictures. Aim to catch them in the action of being the high-spirited individuals they are, not as frozen miniature adults.

Whether you're posing your kids or taking candids, every good picture gives some insight into the child's character. This can be anything from their favorite interest or activity to a simple expression; some of the most evocative portraits of children are taken when they're deep in thought. Keep your camera handy at all times and seize opportunities as they arise.

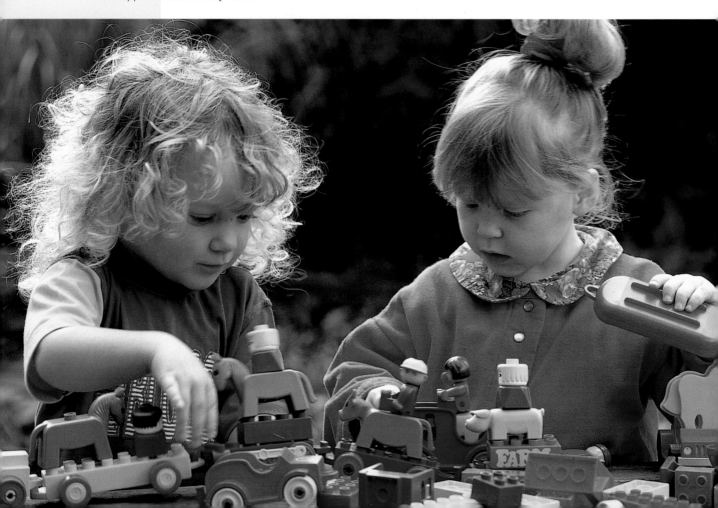

It's fine to start off with a preconceived idea of what you want, but don't be too disappointed if you don't get it. A planned shot can easily turn into a candid one and a candid one may end up as a posed one. Ideas often start to flow after you've taken a few pictures first.

left > Small children don't think much of posing, so it's best to give them something or someone to play with, and catch them unawares. You can still have an influence over the picture, though, by putting the toys in good lighting with a plain, uncluttered background.

right > Children rarely stand still for long so you'll have many opportunities for action shots. For something different, lie or crouch on the ground while they jump from a tree or wall in front of you. With your camera pointing upwards and the sky as your background, they'll look like they're flying through the air. Use fill-in flash to freeze the movement.

ask yourself ?

- Am I capturing the child's personality?
- Does their expression look forced or natural?
- Is this the best lighting that I could use?
- Does the picture have impact?

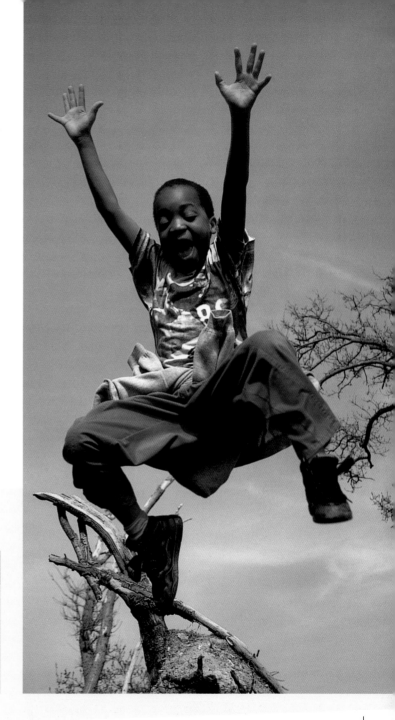

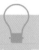

ideas to try

Take a shot of a willing child:

1 sitting in a chair in a relaxed pose, holding a favorite toy. Keep the child talking and take pictures during the conversation

2 Playing, reading, doing homework, or watching TV, unaware of you, then call out the child's name and fire the shutter as he or she looks up

3 Next time a friend comes to play

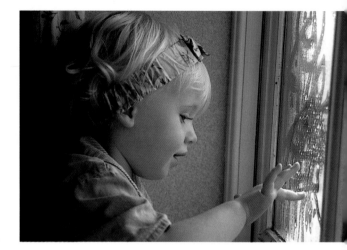

How kids react to the camera varies according to age and personality. Toddlers can be difficult! At this age it's almost impossible to pose them, though a bribe does no harm. Make sure they have a toy to play with, and exercise patience.

If you want a small child to look at the camera, make a game of it. Tell them there's something in the lens— whatever works for them. Alternatively, call their name while they're engrossed in an activity and they'll be sure to look up at you with surprise. If a tantrum ensues, well, why not grab that too? It's all part of family life.

As kids get older, they become more self-conscious. Some will want to overplay. It can be annoying, but go along with it, remembering to fill the frame unless there's a good reason for including the background. If the child is involved in sport, take the camera to matches where you can get posed and action shots. Make sure you get the best viewpoint.

Above all, stay relaxed and you'll probably find your children assisting you more than you imagined. Keep talking. As soon as you start asking them something about school, or the game they're playing, their faces will sparkle; kids love to talk about themselves and life. You'll find you don't know when to stop pressing the shutter.

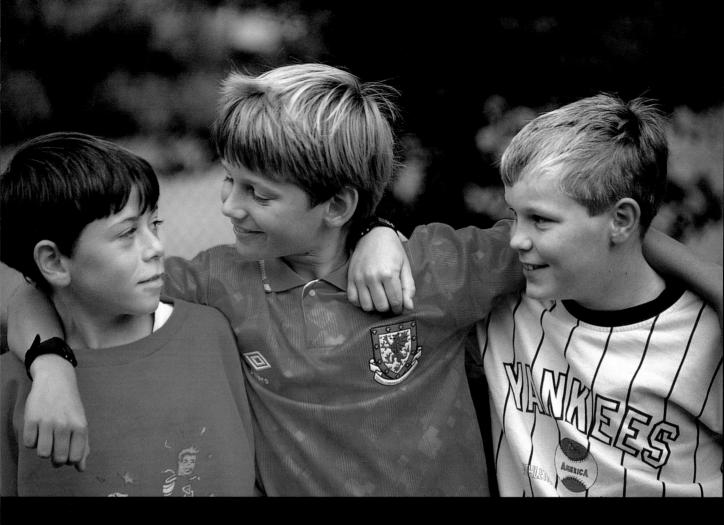

above left > Children are naturally curious and you can get an idea for a good shot by watching what they get up to independently. If you didn't have your camera ready at the time, there's nothing wrong with a reconstruction!

above > When you put a group of kids together, it always looks better if they are linked in some way. The best shots will be those without wide spaces between the subjects.

siblings

Brothers and sisters can argue like cat and dog and declare their hatred of each other five times a day, but underneath it all lies a secret affection. The bond between siblings is different to that of friends. There's an intuitive desire to nurture and protect, as you can see in the eyes of a child who holds and cuddles the new baby. Think of these emotive aspects when taking your pictures and don't throw the kids haphazardly into the frame.

The beauty of posing siblings is that most don't mind getting close, so bring out that family bond by playing on physical and eye contact. Have them put their arms around each other, or the side of faces or foreheads together. For that 'yippee!', happy look, tell them to shout 'strawberree' or 'cookiee' slowly, rather than 'cheese'.

Don't restrict yourself to posed shots. Whether they're playing, fighting, or play-fighting, there are plenty of moments when you can catch them in close contact without them even realizing it.

ideas to try

Arrange a shot of two siblings:

1 in an embrace, face to face with eye contact

2 with the youngest in the foreground—this could be a baby in arms, looking at the camera

3 playing together, using the compositional tools you have learned

Arrange a shot of three or more siblings:

1 with one in the middle, forming a triangular shape

2 with eye contact, all eyes on the youngest, then oldest

3 playing together, the focus on the youngest

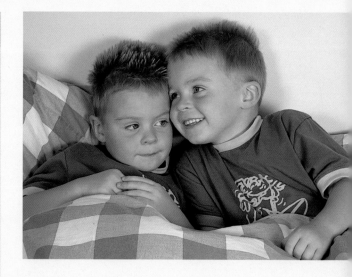

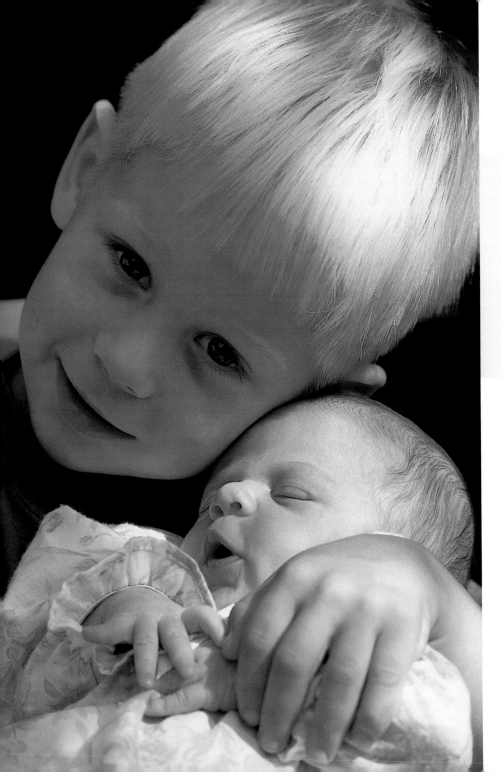

left > It's often easier to pose an older sibling first, before adding the baby. Put the older child's head at an angle, with the baby's following the same line, rather than one above the other. If the older child is too young to hold the baby securely, prop them both up on a bed or sofa with cushions all around.

far left > You can photograph a couple of siblings almost anywhere, so long as the surroundings are uncluttered and not distracting. Their heads should be close together for impact but they don't have to be showing fake grins to the camera.

teenagers

There comes a time in children's lives when they just hate the sight of a camera, and you can guarantee that it's when they become teenagers. Almost overnight, they start to feel self-conscious, and every facial blemish or bit of imaginary cellulite becomes a blight which the entire universe will see.

For this reason, trying to photograph teenagers can be a bit like walking on a tightrope. They feel exposed and vulnerable in front of the camera and become moody and irritable if forced to pose. You feel under pressure to get the picture over and done with quickly, and the result is a poor image.

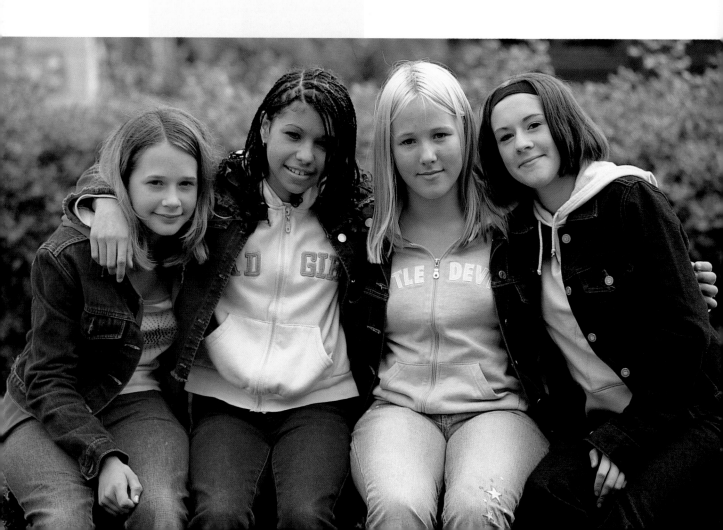

Teenagers have their own ideas about how they want to be seen as they have their image to maintain. The best way to coax them is to let them choose where, when, and how the photograph is going to be done. Let them wear what they want, for this preserves their identity.

If you can get away with them, candid shots work well: teenagers shopping, gossiping with friends (so long as you're not eavesdropping!), or getting ready to go out.

Be sensitive and make sure you're taking pictures they actually like, otherwise you'll spoil it for next time. Remember to tell them how good they look; one bit of criticism and they'll never forget it! Try to make the session fun and be a bit of a teenager yourself—not too much, though, or you'll just embarrass them!

left > Many teenagers become particularly camera shy when other people are around. Others find looking cool with a gang of friends easy, while putting on a face alone is tedious. Let them do what comes naturally.

right > You never know, your teenager might get into the whole idea of posing for some pictures—providing it's on his or her own terms. Let the teenager contribute ideas while you concentrate on lighting and composition.

ask yourself

- What is it about the teenager's character that I can get across in a photo?

- Are they going to like this picture afterwards, or have I pushed them into it?

pets

Pets are considered as much a part of the family as everyone else. Children have a special affinity with them, and they can bring warmth and companionship to the elderly who live alone.

They say never work with animals and children and there's no wonder why. Animals can be even more unpredictable than kids and respond to direction even less, so getting a satisfactory shot of both of them is a bit of a challenge.

Dogs are easy if they are well-trained. Cats can be docile, but have a mind of their own and will only sit in one place if that's where they want to be. Kittens and puppies are too active to sit still, so are best captured when they are sleepy. Rabbits and guinea pigs are usually easy to photograph because they can be motionless for a long time. Smaller pets like hamsters and mice are a nightmare when they're awake because they just wriggle around too much. Even horses can be stubborn. Plan any posed shots around the times when your pet is most likely to co-operate.

`far right >` **An intimate shot of rider and horse can be obtained by standing the owner next to the horse so their heads are close together. Alternatively, sit the owner astride the horse, leaning forward to rest his or her head on its mane.**

ask yourself

- Is the pet being held securely, legs positioned comfortably, hands free of the throat?

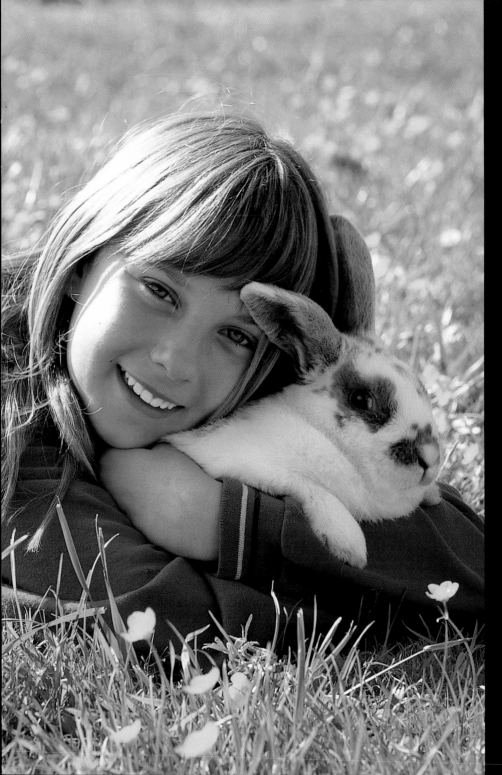

left > Rabbits can stay still for a long time so you should be able to concentrate on the composition and lighting. A close up of the child's or adult's face has impact with a small animal, if it's held next to it. Lying down ensures both are comfortable, and you can use the ground as an attractive but simple background.

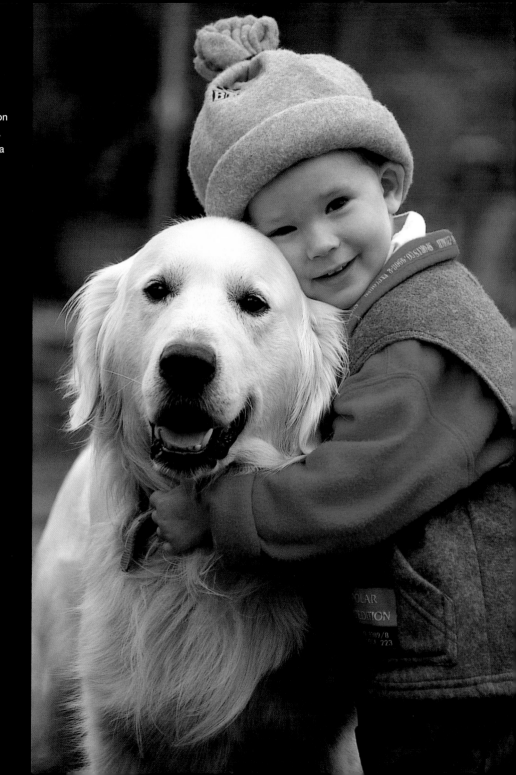

right > This pose is easy to arrange
with a docile dog and shows the affection
between the two and their relative sizes.
The red sleeve of the boy's jacket adds a
touch of color on a dull day, and
contrasts well with the retriever's fur.

left > Kittens are very cute, so why not make the most of it? You need to be quick for a shot like this because it won't stay put. Position the child first, get the camera ready, composing and focusing the picture, then ask a helper to place the kitten at the last moment. Like kids, animals tire of the camera. Don't put the animal under stress for too long.

ideas to try

Pose a child with the family pet:

1 so that he or she has eye contact, hugging, holding up in front of face, or, if a small mammal, cupping the pet in hands

2 holding the pet up to the face, both looking at the camera

3 with the pet on the ground or in its bed and the child close to it but not holding it

A pet and its companion should be close together to symbolize affection. Big dogs can face you, but at an angle or lying down, making sure their legs aren't sprawled out.

Tiny animals can be cupped in the hands near to the face. A larger animal, such as a cat, should be held correctly, cradled in one arm, with its back legs held securely under the other so that its limbs are not dangling. Young children have a tendency to hold onto animals too tightly so it looks as if they are squeezing them. If the animal is struggling to get away, let it go and take the child to the animal and pose him close by.

Actions shots of children with puppies or kittens show the vitality of both, so let them play and shoot pictures of them having fun. With a subject and her dog running towards you, it takes practice to get everything in focus, while you concentrate on composition. You'll need to be quick to catch the action before the dog has run out of the viewfinder!

couples

Most often the only time a couple are photographed together is on their wedding day. After that, one partner is behind the camera while the other poses. A passer-by might help, but it's a gamble whether they'll take a good picture.

If you and your other half don't always want to be segregated, pop the camera on a tripod or table top and use the self-timer. This delays the exposure by about ten seconds, allowing you to run into the picture. You first need to frame the shot in the viewfinder, leaving space for yourself. If you're not sure how to pose for your portrait, stand in front of a mirror and experiment, trying out a few ideas from the posing section in this book.

If you're taking another couple's picture, it helps to know something about their relationship so you can portray them in a realistic way. Ideally you want them to be close together, but it's no use having them gaze all starry-eyed at each other if that behavior is alien to them. With some couples, public displays of affection are completely normal, in which case you'll have no problem getting them to cuddle for the camera.

However you pose a couple, your image should reflect their feelings. It need not be posed. They can simply be enjoying each other's company.

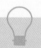

ideas to try

Depending on the couple, pose them:

1 sitting apart

2 next to each other, heads inclined and arms around each other

3 face to face

4 in conversation, just being natural

5 with any props that may say something about them

right > It can be great fun taking a picture of a couple you know well, so long as you don't take the whole thing too seriously. They will probably find the experience of posing quite funny, which will give you the spontaneous expressions you're looking for.

far right > People often feel more relaxed about posing if they are sitting down. Steps are useful for sitting one partner slightly behind the other, arms around their shoulders. It creates a more interesting shape than if they are side by side, especially if one person is taller than the other.

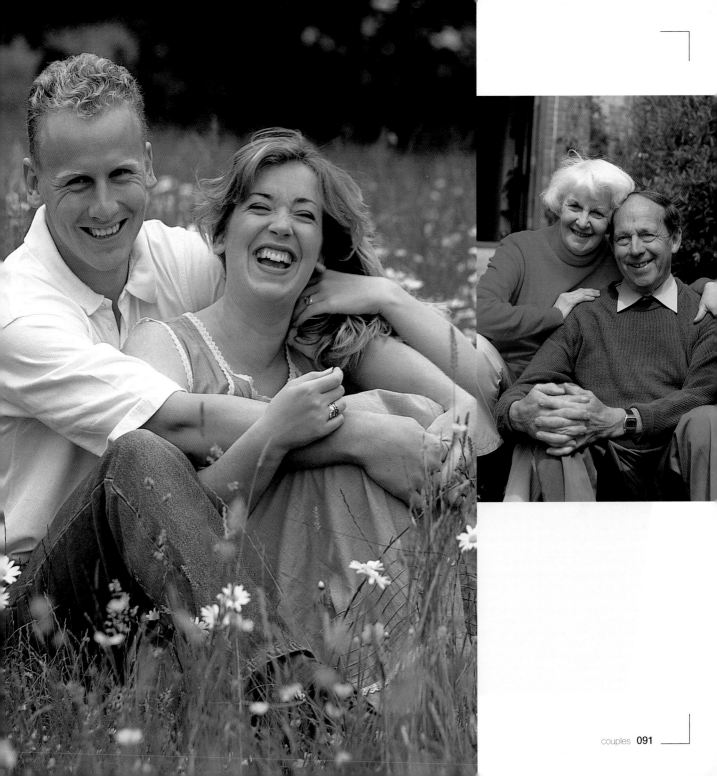

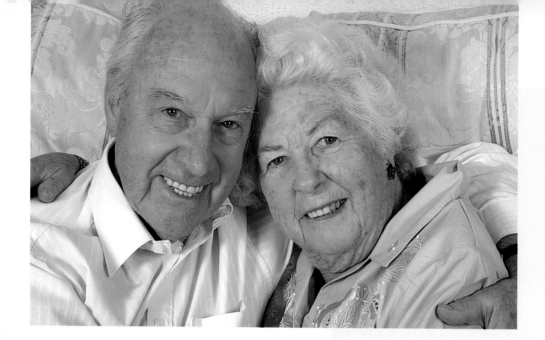

grandparents

While grandparents often receive photos as gifts, they rarely appear themselves. That's a shame. As with younger couples, make the most of their personalities. The very elderly have faces full of character and wisdom, so get some tight shots of their features. Have they been through tough times? Are they gentle or funny? Do they sparkle with life?

Be careful when photographing people with spectacles as any flash will be reflected in the glass. It's best to avoid flash altogether, but if that isn't possible, ask the subject to remove his or her glasses, unless it will change their character, or have them look down slightly. Otherwise their eyes will look like a pair of flying saucers!

Retirement means there's time to pursue an interest, and a picture is more revealing if you include this. Whether it's a couple gardening or walking, fill your pictures with information. Include intimate pictures with the grandchildren, too, perhaps cuddling a baby or chatting with a teenager.

ask yourself ?

- If my photos were the only information future generations had about the family history, what would they want to know?

far left > A tightly-framed portrait can reveal a lot about people's characters. Always focus on the eyes as these are the most important feature. Use natural daylight from a window if you can, or ask the subject to step outside.

left > It's lovely to have some cross-generation pictures, like a grandparent holding a baby, reading a book to a toddler, or talking with a teenager.

family groups

Family get-togethers are generally times when cameras come out. It's worth taking the trouble to arrange one picture of the entire family unit. Everyone will appreciate it, and you'll have plenty of requests for reprints.

The only way to include yourself in the picture is to use the self timer, but be warned. You'll have spent time setting up your shot, ensuring your composition and lighting is right, that there's contact between the subjects, and no-one's face is masked by their neighbor. The minute you take your pew, someone will have inched into your space, moved away, or looked away from the camera. To avoid this, arrange a few casual compositions, for example round a sofa or on a park bench, so that everyone has a bit of space to maneuver and no-one invades your territory. Make it quite clear to all parties that you are coming into the shot and they must stay put and focus on the camera lens. It can be a bit hit or miss, but it's a great way of breaking the ice at a party!

Whether you're taking posed or casual pictures, everyone in the family should cohere. Remember that focal point: is the family going to look at the camera, or is the baby the focus of attention? Once you've decided, make sure your relations are all facing in the right direction. It's no easy feat—be prepared to use plenty of film.

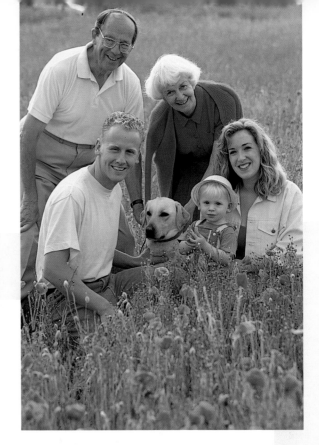

ask yourself

- Are all my subjects looking happy and in the same direction?
- Does the whole picture tie together as a family unit?

above > Taking group shots on a self-timer can be a bit hit or miss. You can support the camera on a table top but a tripod is better because you can vary the height. Practice the pose first, allowing room for you to enter the shot.

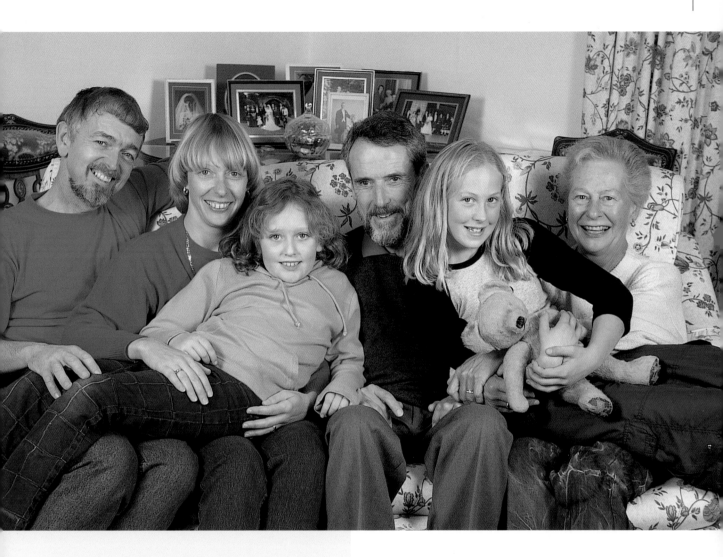

above > Family outings are a great chance to take a group shot that will be valued in years to come. If your shot involves animals and young children, arrange the pose as quickly as you can before boredom sets in.

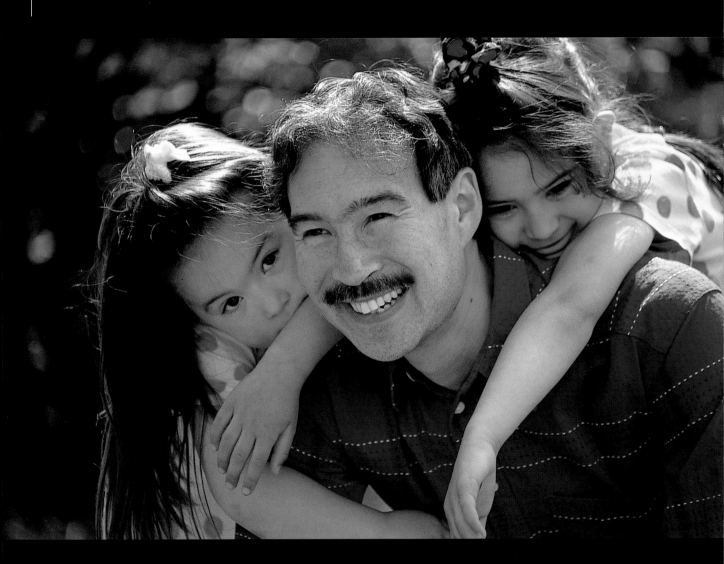

above > Look out for candid shots of a parent relaxing and having fun with the children. You can't plan these pictures, so keep your camera handy. A zoom lens is useful to frame in tightly without having to move your position and spoil the moment.

right > A relationship between a child and its parent can just be implied, without having to include both figures in the picture. By crouching down to the boy's level here, the difference in size between him and his dad is emphasized but the closeness between them is apparent.

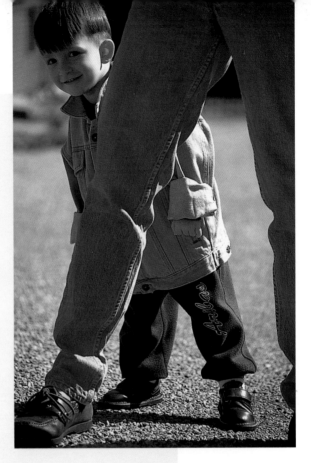

ideas to try

While you've got the family together, pose them:

1 in a tight composition together, looking at the camera

2 in an informal pose, scattered about but with not too much space between them

3 one parent and one child looking at the camera

4 one parent and child involved in an activity

Babies and small children with a parent or relative make exceptionally attractive subjects for the camera. Kids wallow in undivided attention, which makes candid photography really easy. Tell the parent to keep talking to the child so his attention span doesn't wane. If you use a zoom lens and keep a discreet distance from the pair, the child will forget you're there and the parent will feel uninhibited.

Emphasize intimacy. A mother's arms around her toddler looks more harmonious than if they're seated separately. Make the most of special moments and fun times with the child or children: bath times, story times, and those conversations when they're asking complicated questions. A baby will enjoy games, and kisses, and tickles. Remember that you don't have to include everything in a picture to make it work. A close-up of a wistful child holding a parent's hand is enough to symbolize the relationship between them without having the entire adult in the shot.

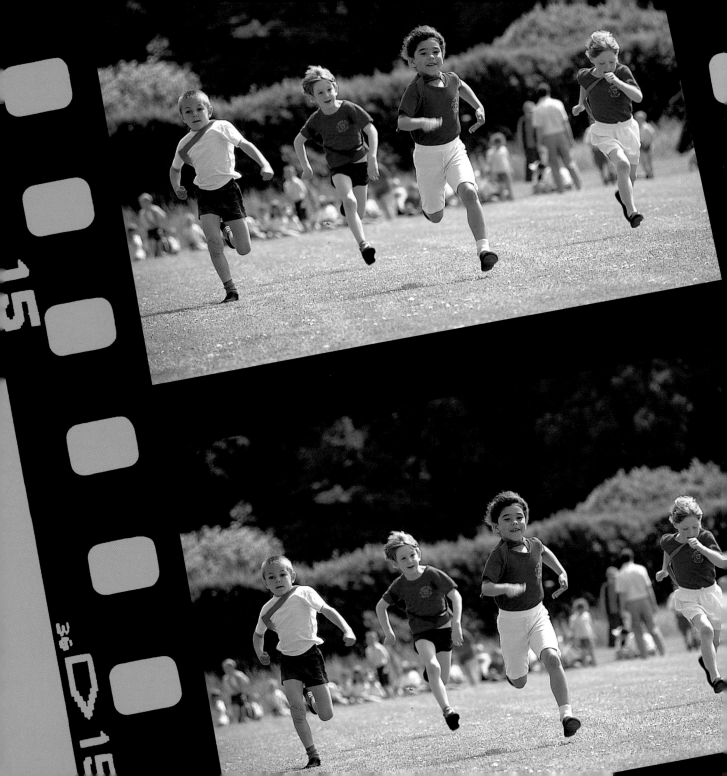

special
occasions

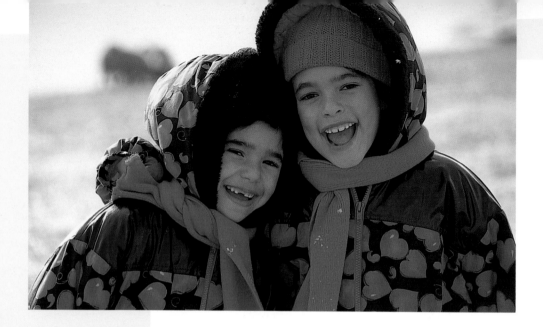

everlasting memories

A celebration is a great opportunity for building a family record, from a baptism to a birthday party. Christmas, weddings, and vacations all provide valuable memories that will readily come to life with the aid of your photo albums.

Special occasions are a time when relatives get together for the first time in years. The last thing you want to do is round them up for a picture the minute they walk in—they'll be too immersed in catching up. Wander round discreetly with your camera, and take some candids of people chatting. When everyone is ready, group them together for a shot.

Whatever the event, make sure you're stocked up with plenty of film. Include a couple of rolls of ISO 200 or 400 for those unavoidably dimly lit scenes indoors. Save the slow speed film for when the weather's good outside.

above > Christmas offers many opportunities for great family pictures, such as the ritual walk following lunch to burn off the Christmas turkey. Fun, relaxed photos like this one of the children out in the crisp, winter air will have lasting appeal.

right > Family parties offer a good opportunity for informal pictures of people chatting and catching up with news. If you're quick and discreet they won't notice you taking pictures and you'll be able to capture natural expressions.

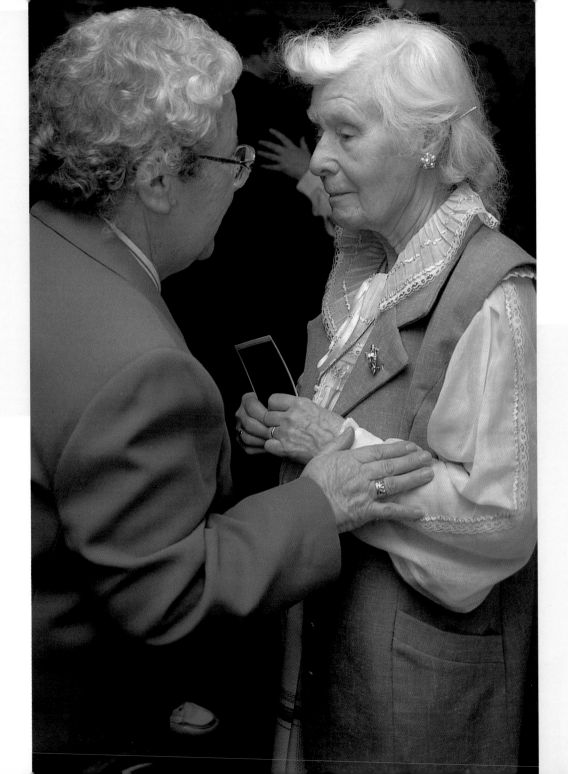

weddings

Every couple wants a photographic record of their wedding day and many hire a professional. In the end, though, it's the incidental pictures taken by family and friends that mean the most. The day passes in a blur of emotion for the couple, and they'll have missed all kinds of crucial details.

If a professional photographer is present, there's little point in repeating their pictures—it's guaranteed to annoy them as well. Instead, fill in the gaps; perhaps the bride or groom getting ready beforehand, or the party afterwards.

Weddings offer a great chance to capture relatives who don't often see each other. Try out your posing techniques or use a zoom lens for candid shots. Look for the happiness of the occasion: people sharing a joke, or laughing at the best man's speech. Capture the flavor of the whole day, from the couple themselves to the cutting of the cake.

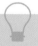

ideas to try

1 Look for expressions on people's faces—it's an emotional day. No-one wants to be caught looking bleary-eyed and worse for wear, though

3 Try using black-and-white film, especially indoors and without flash

left > **If you're a close friend or family of the bride, you can start your record of the day with the pre-service preparations at the bride's home. It's a nice touch to the wedding album, helping to set the scene for the big event.**

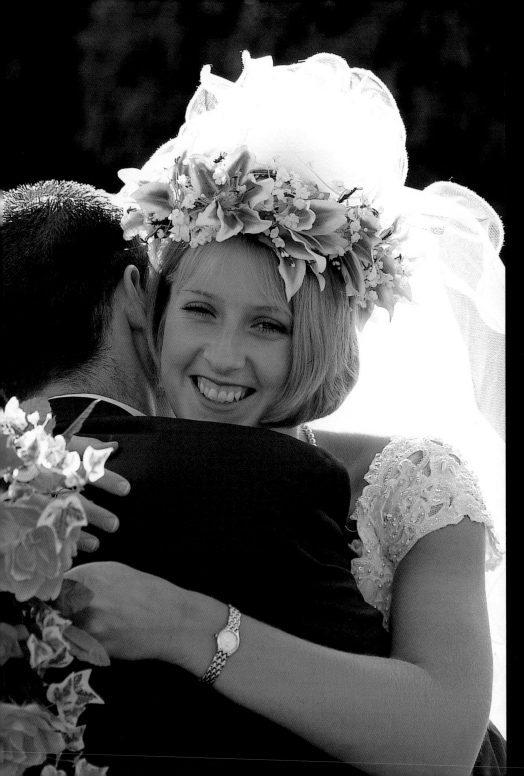

left > While the professional photographer concentrates on the posed line-ups of the wedding party, you can look for spontaneous moments capturing the atmosphere and emotion of the day.

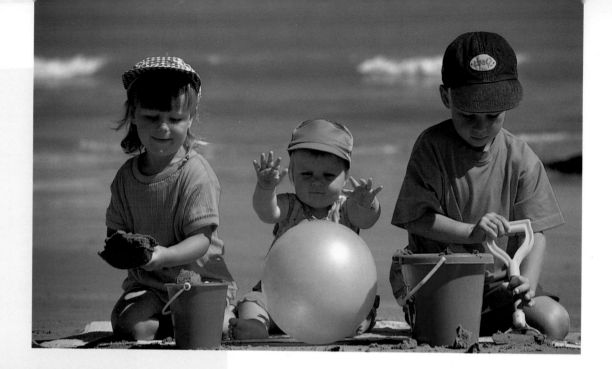

vacations

Along with a bottle of sunscreen, a camera is an essential item in the vacation luggage. Everyone wants to come back with their memories captured on film and it's fun to show the others back home where you've been and what a great time you had. Too many vacation snaps are just that: snaps. They frequently include too much sky, and family members feature as heads in the bottom of the frame. The panoramic view that seemed stunning in real life appears hazy and distant, and the kids are either squinting into the sun or looking bored and fed up with having another picture taken.

Why do vacation pictures go wrong? Mainly because we get over zealous with the shutter button, and ignore what's in the viewfinder. Half a dozen really good shots are far more worthwhile than a whole pack of disappointing ones.

Take advantage of the extra time on your hands and look for new ways to photograph the family on vacation. You could build a picture story: arriving at the airport, the hotel, the first day on the beach, an evening meal, and so on. Keep your eyes open for details that will help you remember the place, then strategically place a family member somewhere nearby. They don't always need to dominate the picture but should look balanced within the location.

ask yourself

- Does my picture contain more than one-third sky?
- Is the pose good?
- Where is the sun? Is it a flattering light?
- Are there any props to hand I can use to enhance my picture?

left > Children love to play in the sand, and getting them engaged in an activity produces more natural pictures than static poses.

right > You should have plenty of time on vacation to get the best out of every shot. A family portrait like this can be thought through before you put the people in the picture. You can also afford to wait until the light will give the best results, which is often a bright day with some cloud cover to diffuse the sun.

ideas to try

1 Sit a child on the beach under strong sunlight. Look through the viewfinder. Get down to their level. Now introduce colorful beach toys

2 Introduce a huge brightly colored umbrella and sit the child under it, with the toys. Judge the difference

3 What is around you that would give a vivid memory of the place? Put your subject there, using all the compositional tools you have learned

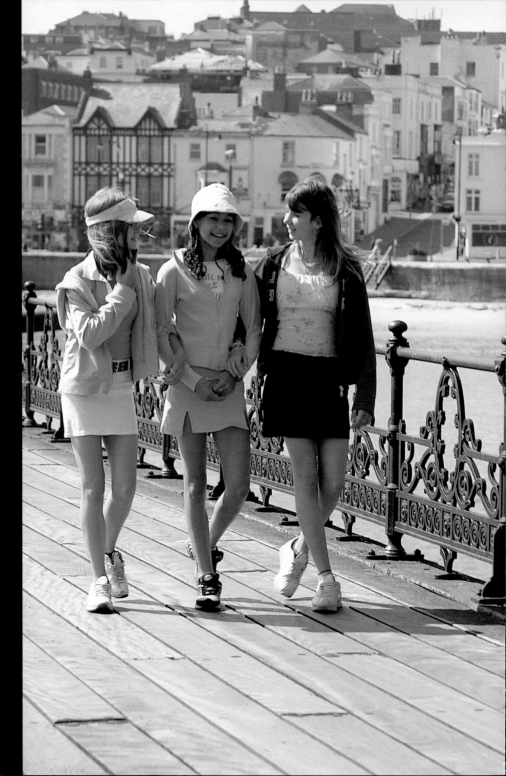

right > While close-ups often have a lot of impact, you'll want some record of the place where you went on vacation. Keep your eyes open for details that will help you remember it and then place family members within the scene. Make sure they are neither too big nor too small in the frame.

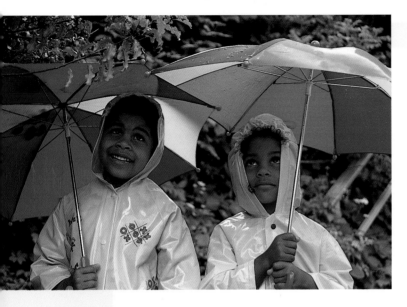

Expanses of sky are a feature of beach vacations. It's wonderful for sunbathing, but won't add much to your photos, so keep it to a minimum. Keep your eye on the horizon to ensure that it remains level, to avoid that 'seasick' look.

Encourage children to build castles or explore rock pools. Pack inflatable rings that they can play with. Pails and spades are ideal for a dash of color, along with bright swimsuits and sun hats. A giant umbrella will protect the children from the sun, provide a vivid contrast against a blue sky, and diffuse the lighting on the people beneath it.

Water is a powerful reflector of light. Your camera may be fooled into metering the highlights, and your subjects will be thrown into darkness. You must overexpose the picture to compensate, or use a polarizing filter to cut down the reflections. If your camera doesn't allow you to do these, try going in close so that your camera meter is on the subject's face, then recompose the picture. For a wider view, use fill-in flash to freeze the action of splashing waves.

The weather makes a difference to any vacation. It's nice when the sun is out, but when in heavy cloud or rain your pictures can look flat. Don't despair. Make the most of an indoor funfair or arcade, or brave the bad weather (many compact cameras are weatherproof). Use a multicolored umbrella and bright raincoats to spice up a dull day. If you're lucky, the sun will peep through a gap in the clouds, producing atmospheric lighting.

christmas and birthdays

These two events are highlights of the year for children. Forget posed shots, just pick your viewpoint carefully, and be ready to capture their faces as gifts are opened. Remove torn paper as you go so that it doesn't clutter up your pictures.

At any party where there's a meal involved, it's a good idea to get group shots out of the way while the food is intact. The scene will look like a disaster zone with leftovers and screwed-up napkins everywhere. Make sure the table is arranged nicely, perhaps adding colorful party hats and balloons. Then gather everyone around before they start to eat.

If it's a birthday party, position the cake in the middle of the table with the star attraction behind it and a tight composition of guests at either side. Rather than look at the camera, they can watch the birthday boy or girl blow the candles out. Try to use existing light with your camera on a tripod for a long exposure.

At Christmas, take pictures of the family dressing the tree, hanging baubles and placing tinsel, being careful that their arms don't cover their faces. Capture their expressions as they focus on the task. Fixed grins make the whole thing look horribly contrived. Wait until the tree is finished for a posed shot of the family and a few presents around it.

ask yourself

- Does this arrangement sum up the event?
- Are all the faces visible and not blocked by trimmings, etc.

left > **Try arranging the children around the cake at a party. The birthday treats add to the atmosphere of the shot but make sure you take the picture before the children have demolished them.**

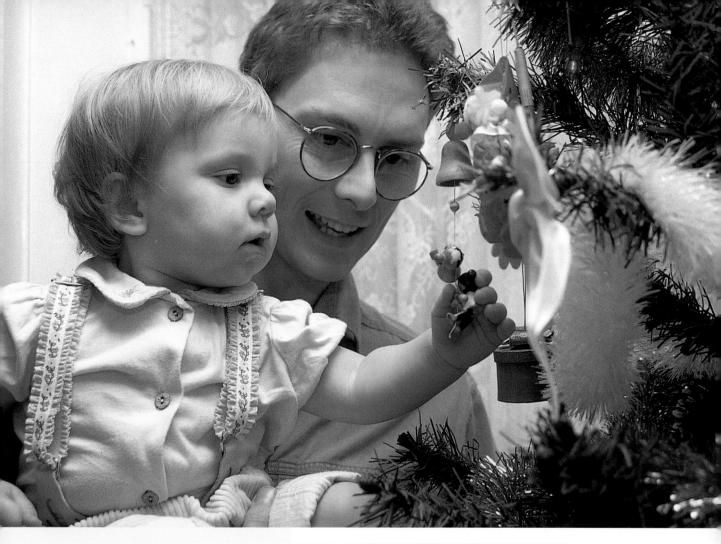

above > **Decorating the Christmas tree can produce some nice shots. Look for natural expressions of excitement or concentration rather than forced grins or stiff poses.**

ideas to try

1 Take pictures of the kids out carol singing at night. Use lots of lanterns, a very fast film and the camera on a tripod.

2 Gather everyone around a piano, or the Christmas tree, for a sing-song.

school events

Children enjoy many achievements through their school lives. These often go unrecorded because it's not easy to get cameras into schools, unless they belong to professionals taking posed portraits.

All parents are invited to sports' days, however, and these offer a great chance to photograph children in action. Races are predetermined, which means you can find yourself a position in advance. Stand close to the finishing line, or lie on your stomach for a low angle of the kids running towards you. You don't want your child dot-sized in the frame, nor do you want to crop out competitors. Once the starting whistle is blown they shoot off in all directions, making composition difficult. Pre-focus on the spot where your child might end up, ready to fire when she runs into the frame.

Parents also attend concerts and school plays, and they'll want to take pictures. Some schools will make you wait until the performance is over, which isn't a bad idea since you'll be able to get closer to the stage and use flash within its range if you need to. Better still, ask if you can take pictures during the dress rehearsal so you can relax and enjoy the real thing. If the room has enough natural light coming in, avoid flash, using fast film and a tripod instead.

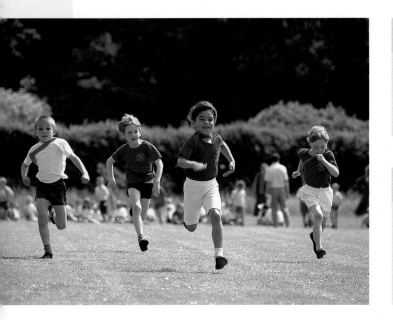

ask yourself

- Is this the right film—fast or slow, daylight, or tungsten?
- Do I need to use flash. If so, am I close enough?
- Is this the best vantage point?

ideas to try

At a school sports day, match or play, take pictures:

1 of the children getting ready

2 that target your child with at least two others nearby

3 which isolate your child in action

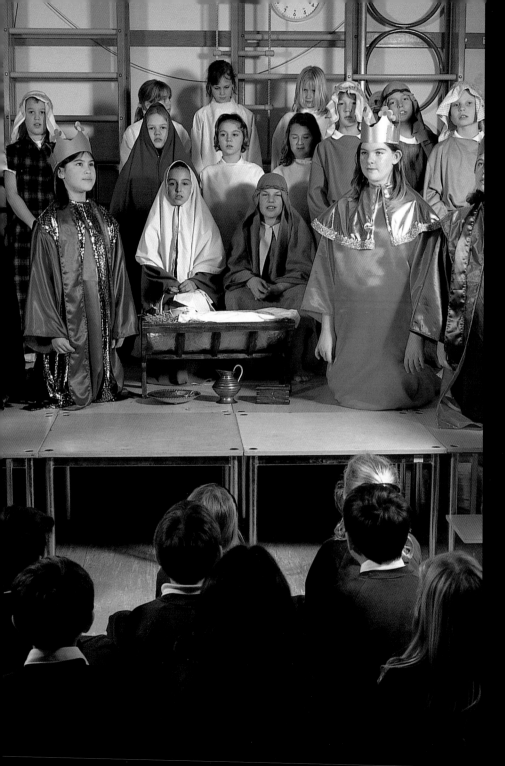

bottom left > **For a race at a school sports day,** take up your position near the finish line and keep your fingers crossed that your child reaches it first, with a few others close behind! You'll need plenty of fast film and quick reflexes to get a striking shot.

left > **Schools have different policies** about photography during plays and concerts. It's worth asking permission to take your camera to the dress rehearsal; you could offer to give the school some copies of the pictures in return.

after
thepictures
aretaken

6

organizing your pictures

As your enthusiasm for family photography grows, so will the number of your pictures. It's doubtful they'll all be perfect, so get into the habit of editing ruthlessly, and discard any photos that don't come up to standard or are redundant.

The best of your pictures will look even better if well-presented. It's a good idea to organize them as soon as they return from the processors or are extracted from a digital memory card. If you leave it too long, they'll mount up and the task of organizing them will be so daunting you'll keep putting off the job. If you store your images without cataloging them, you'll have a hard time tracking down a picture when you need to.

The first thing you should do when you pick up your pictures is jot on the envelope the date, location, general picture content, and number in the order in which you took them, e.g. month/year/holiday/1. That way you'll have a quick reference guide when you come to put them together, since subjects have a way of being split between films. Whether you enlarge or frame favorite shots, display in albums, or on your computer, viewing should be effortless.

left > Special memories of your children's significant
events, achievements, and friendships should be treasured
and displayed in albums or kept on your computer to print

above > Family photography doesn't end once the shutter
has been pressed. There are all sorts of ways in which you
can improve and enhance your results. You can also use a

processing and printing

The question of where to get your films processed is typical. It depends on the desired quality of service, how much you want to pay, and how quickly you want the pictures back. Test out a few labs, and find one you are happy with.

Choices range from shopping mall mini-labs (which can turn around prints in an hour) to mail order, which can take up to two weeks. Some labs return your pictures with a free film. If they provide a free index or 'easyfinder', this is an advantage as it gives you a quick reference guide to your prints. Some labs only print color film, others extend to black and white, and transparency. The latter uses a different processing method (E6) to print film (C41).

Many photofinishers put your pictures onto a CD for an extra fee so that you can download them onto a computer and print out selected images, provided you have the right equipment (see overleaf).

When your films reach the processors, unless you have asked for hand prints, they will be developed and printed in a computerized processor. How your prints come out depends on who operates it. They should make adjustments for color and compensate poor exposures, but some will do it better than others. Do complain if you think they've done a bad job. Good customer care means they'll try again for you.

Don't be too quick to blame them, though. It could be that your negatives were too badly exposed. There has to be enough detail in them to produce a decent print. Hold them up to the light and if you can hardly see an image, it means they are too underexposed, and printing them again won't make any improvement.

When deciding print size, think about how you are going to present them. A standard sized 'enprint' measures 4x6in, but 5x7in prints are also available. Albums and frames are available for both formats.

left > **Professional labs can make up a contact sheet of a black and white film. This allows you to select the best pictures for printing without wasting money on bad shots.**

2.1 or 14.

above > If a processing lab can provide an index print or 'easyfinder', this is an advantage as it gives you a quick reference guide to your prints. APS films are returned with one as a matter of course.

The next consideration is paper finish. Gloss prints have a shiny surface that tends to show up fingerprints when they've been passed around a few hands. Silk or matt finishes look a little muted by comparison, but they don't mark so easily. They look attractive in photo albums and framed behind glass. For an additional sum, take up special offers like an extra set of prints. Someone will always want a repeat picture.

digital imaging

There are several ways of obtaining digital images, all of them requiring a computer. You can shoot pictures on a digital camera and then download them onto the computer. You can also 'digitize' ordinary negatives, prints, or slides by scanning them into the computer. Flatbed scanners can manage prints up to foolscap (A4), and some have a slide facility. Film scanners are for 35mm negatives and slides, and are more expensive. If you don't want the expense of buying a digital camera or scanner, ask the lab to do a Photo CD for you. This slots into the CD-ROM drive of the computer.

So why put your pictures on a computer? If you have access to e-mail, it's a great way of showing your pictures. Attaching photos to a message is easy, and cheaper than ordering and posting reprints.

below > **Photo-imaging software opens up all kinds of creative possibilities.**

above > Inkjet printers are affordable and efficient for digital imaging at home.

manipulating pictures

The beauty of digital images is that you can manipulate them: enhancing brightness, contrast and sharpness, retouching, and getting rid of red-eye. You can even add a missing family member to a group shot. To do all of this and more, you need image-editing software. There are many available, ranging from low-cost and beginner-friendly to those aimed at professionals. If you don't want to splash out immediately, free demo samples are often offered with computer magazines.

printing your images

Once you've achieved the perfect picture on your computer monitor, you'll want to print it out. Plain paper won't do it justice, so invest in special coated paper. There are many different printers on the market but inkjet printers are the most popular and have become less expensive and better quality in recent years.

An alternative to home printing is to transfer your picture files onto a disk and take it to a mini-lab that offers a digital service. They produce excellent quality prints, although at a greater cost than if you do it yourself.

building a picture story

Although you shouldn't keep a lot of repetitive shots, the exception is when you have pictures that follow a series of events that tell a story, revealing much more than a single picture. This can happen by accident, or it can be planned.

A picture story can be an account of something lasting a minute or two; perhaps some action shots taken at speed with a motordrive. A short sequence can happen while watching a child at play, maybe in an imaginary role as parent nurturing a soft toy or doll. He washes it, feeds it, dresses it, and puts it to bed. Or it could be an equestrian event: dressing a pony, the show jumping competition, the presentation of a ribbon.

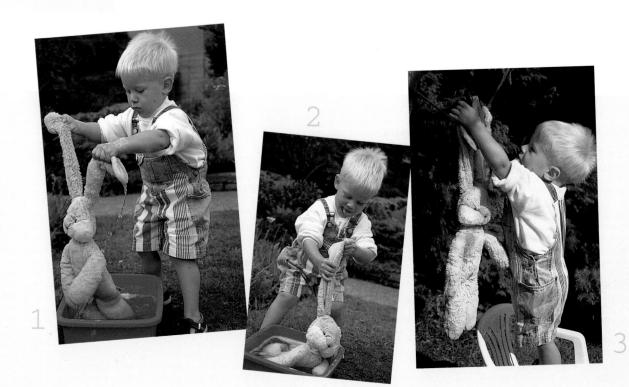

A story could also happen over months or years, starting with birth, first tooth, first steps, and first birthday. Plan the sequence so you take a portrait of a baby or child in an identical setting over a period of time. Begin in the first few days of a baby's life. Repeat the same picture every month over the first year, using the previous picture for reference. Use natural light at the same level, and a similar composition each time. It's a great way to reveal a baby's changes.

There are many other ideas for planning a picture story. Arrange the pictures together to make a display in an album. Better still, display the story in a frame. You can buy ready-made frames or have one made specially.

below > A child engrossed in a make-believe game or 'grown-up' activity can make a delightful picture story. Just as if you were writing an essay, the story should have a beginning, middle, and end.

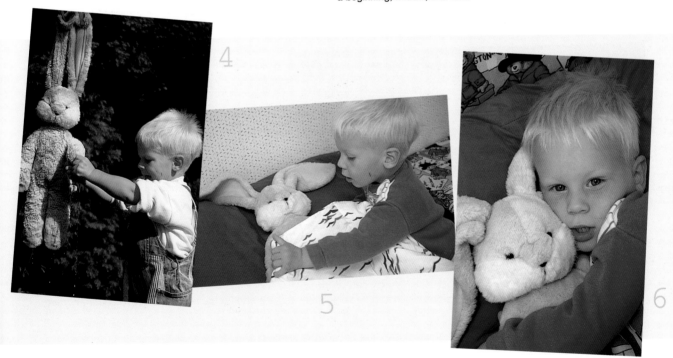

creating an album

There's nothing worse than passing prints around family and friends and getting them back in a muddle or with grubby marks. It's a shame, too, to consign them to a cupboard after the thought that went into them.

The easiest way to view and protect them is in a photo album. To begin, sort your prints into themes, such as a holiday. Group them so that color balances, and vertical or horizontal shots are together. Captioning each page will be helpful when you view the pictures later, and viewers won't have to question you about where every shot was taken. Store your negatives in a cool, dry place, and in special sleeves. Organize these in a binder with an identification code.

Investing in materials that are termed 'archival' ensures that prints or slides survive longer. Non-archival (PVC) materials contain certain substances that can damage your photographs over a long period of time. Light, heat and humidity can also cause damage, so take precautions against these elements.

Photo albums are available in many forms, but the flip-up variety is great for family photos and can take about 80 prints. Watch out for economy versions which can be very flimsy and are often a fraction too small to accommodate standard prints. Albums with plastic overlay and self-adhesive pages only take four standard prints to a page, but allow you to make your own arrangements. Occasionally the overlays and sticky backing lose effectiveness after a while, especially if you remove and replace the prints. Traditional albums are especially attractive for

selective pictures. These have black or white pages, each overlaid in a light, translucent paper rather than a sticky overlay. You can mount your pictures with photo corners or sticky invisible mounts.

Whatever you choose, outshine the typical album by narrowing down your presentation to only the very best and relevant shots.

top left > **Choose only your best pictures to present in an album and keep the negatives for furture reprints.**

above > **Photo albums are the best way of protecting pictures and making them accessible. You can arrange them chronologically, or according to a theme. Do label them to jog your memory later on.**

enlarging and framing

The standard size enlargement for a 35mm negative is 10x7in or 12x8in. A 10x8in picture doesn't match the ratio of a 35mm negative blown up, so if you want this size, expect to lose part of the image. Enlarging beyond 12x8in is not recommended if you have shot on ISO 400 film with a compact camera. The bigger your enlargement, the more visible the grain and the more evident poor-quality lenses become.

Choosing a frame for a photo is just as important as for a painting. Ready-made frames are available in many varieties, from the very simple to the ornate and gimmicky. Avoid the latter as frames draw your eye away from the picture and, when all's said and done, it's the picture that demands attention.

Black frames set off black-and-white photographs well. For color prints, you may choose a frame that co-ordinates with your décor. But first take into account the color and content of the photo and pick a frame that complements it. Something heavy is not suitable for a delicate picture, and a thin frame is too insubstantial for bold prints.

ask yourself ?

- Have I got a lot of bad pictures that really should be binned?

- Would any of my shots benefit from framing and enlargement?

- Are my pictures protected and arranged for easy viewing?

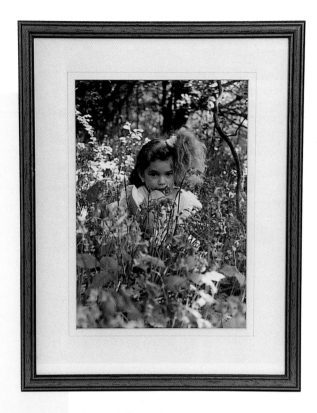

ideas to try

Make a montage of assorted family snaps. Cut them down to crop out unwanted details, and arrange them on a sheet of card. Stick them down, overlapping slightly, and frame.

professional framing

Taking your photo to a picture framer will give you more options and professional advice. You can get your print mounted behind a bevelled mount board before framing it. This has two advantages: it prevents the print from being in direct contact with the glass, which can cause condensation, and ruin your photograph, and it makes your picture really stand out, too. For a 12x8in print, the mount needs to be between two and four inches wide.

Test your photo against a cream mount is a good start as this tends to go with anything. You can choose another color if it doesn't work. You can lift out your photograph further by adding a secondary mount beneath the main one. Ideally, it would be a hint of color taken from your photograph. Don't go so mad that it detracts from the image.

Ask the framer to dry-mount the photograph. This makes the picture lie flat and bond permanently. The difference between a picture that has been dry-mounted and one that has no adhesive backing is obvious—the latter is creased. Prints fade over time. Take precautions and keep framed photographs out of direct sunlight.

20 questions to ask yourself

- What is my main subject?
- Is it a single shot or a series?
- Is it candid or posed?
- Do I have the right film in my camera?
- Is my camera turned on, and lens cap off?
- Is my camera stable? Is it straight or lopsided?
- Is my finger or camera strap covering the lens, flash, or metering sensor?
- Am I within the minimum focusing distance of the camera?
- Is the camera set to focus on the main subject?
- Where is the light falling on my subject?
- Do I need flash?
- Have I scanned the edges of my viewfinder?
- Is there anything drawing my eye away from the main subject, or any objects growing out of heads?
- Do I need to include the background?
- Is a horizontal or vertical shot most suitable?
- Is this the most interesting angle to shoot from?
- Would any props enhance this picture?
- Are my subjects comfortable and all looking in the right direction?
- Is there some kind of unity between the people in my picture?
- Does their pose, expression, or environment tell me something about them?
- Finally—fire!

acknowledgments

Angela would like to thank Charlotte and Maya.

Cathy would like to thank the team at RotoVision, and her family, Giles, Harry, and Finn, for providing love and inspiration.

15 FUJI

index

A
action shots 79, 89, 110
albums 121, 122-3
aperture 16, 3
APS cameras 18
archival materials 122
autofocus lock button 33
automatic cameras 33

B
babies 74-7
backlighting 13, 58-9
balance 34
birthdays 108-9
black and white
photography 22, 74,
 102, 116

C
cable release 21
camera
 choice of 18-19
 how it works 16-17
camera angles 48-9
camera shake 20, 24-5
candid shots 85, 96,
 100, 102
celebrations 100-101
children 78-80
Christmas 108-9
color film 22, 116
color in composition
 50-51
compact cameras 17, 18
 flash 68, 74
 viewfinder 28
couples and pairs
 43, 90-91
cropping 29, 46

D
depth of field 31, 33

diffused light 61
digital cameras 16, 19
digital imaging 118-19
directional lines 37
domestic lighting 65

E
enlargements 22, 124
exposure 16-17
 flash 66
 indoors 65
 near water 107

F
f-stops 16, 33
families 72-3, 94-7
fast film 17, 110
fill-in flash 66, 68, 79
film 22, 110
 tungsten 65
film speed 22, 100
filters 20
 polarizing 21, 107
fixed focal length lens
 18, 31
flash 8, 9, 12, 18-19, 62,
 66-9, 74, 110
focal point 30-33, 94
focus 30
framing 121, 124-5
framing subjects 46-7
front lighting 58, 60

G
grain 22, 124
grandparents 92-3
groups 44-5

I
index prints 116-17
indirect lighting 61
indoor light 62

instamatic 18
ISO number 22

L
length of lens 31
lenses 18
lighting 56-69
lighting conditions 17
line of gaze 34
long lens 31

M
manipulating pictures
 119

O
organizing your pictures
 114-15, 122

P
perspective 31
pets 86-9
picture story 120-21
pixels 16, 19
point and shoot 18
portraits 22, 38
posing 38-45
print finish 117
print size 116, 124
printing 119
prints 22
processing 116-17
props 50-53
publication 22

R
red-eye 12, 69, 119
reflectors 20, 62, 68
rule of thirds 34, 35

S
scanners 118

school events 110-11
self-timer 18, 90, 94
shutter speed 16
siblings 82-3
side lighting 58
single focal length lens
 18
single-lens reflex cameras
 see SLR cameras
single people 40
sitting poses 42
slides 22, 116
SLR cameras 19
 depth of field 33
 flash 68-9, 74
software 19, 119
standing poses 41

T
teenagers 84-5
transparencies see slides
triangle 38, 44
tripods 20, 25, 62, 90,
 94, 110

V
vacations 104-7
viewfinders 28-9

W
weather 107
weddings 102-3
wideangle lens 33, 48

Z
zoom lens 8, 18, 46, 75,
 96, 102